IMAGES Sammarco, Anthony Mitchell.

New Bedford

NE

DATE DUE

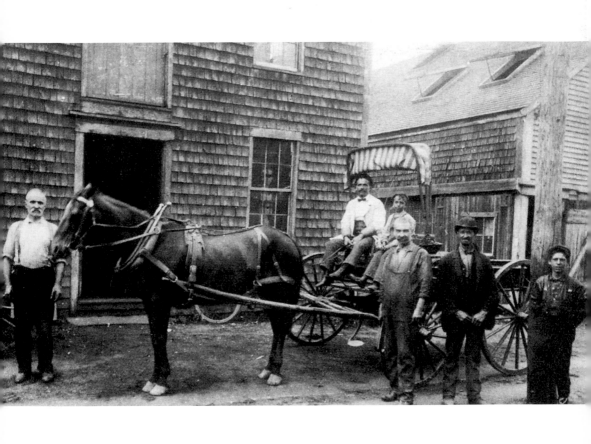

IMAGES OF AMERICA

NEW BEDFORD

ANTHONY SAMMARCO & PAUL BUCHANAN

ARCADIA

Frontispiece: The driver of the horse-drawn wagon, A.E. Perry, has stopped in front of the New Bedford Reed Company on Water Street in 1904. Perry's son Manuel is by his side; the other men include M.D. Martin (owner of the shop), J.D. Martin, and Mr. Soares.

Copyright © 1997 by Anthony Sammarco and Paul Buchanan
ISBN 0-7385-1285-0

First published 1997
Re-issued 2003

Published by Arcadia Publishing
an imprint of Tempus Publishing Inc.
Charleston SC, Chicago, Portsmouth NH,
San Francisco

Printed in Great Britain

Library of Congress Catalog Card Number: 2003107000

For all general information contact Arcadia Publishing at:
Telephone 843-853-2070
Fax 843-853-0044
E-mail sales@arcadiapublishing.com

For customer service and orders:
Toll-Free 1-888-313-2665

Visit us on the internet at http://www.arcadiapublishing.com

Contents

New Bedford, Massachusetts

". . . the dearest place to live in, in all New England."
—Herman Melville, *Moby Dick*

When Herman Melville shipped aboard the whaleship *Acushnet* in 1841, he was clearly impressed by New Bedford's opulent homes with their emerald lawns and gardens and the enormous wealth of this burgeoning seaport. But he was equally struck by New Bedford's cultural diversity. Indeed, Melville devotes almost a chapter describing how people of every background could be found on New Bedford streets, drawn here from all over the globe, lured by the promise of wealth and adventure.

Toleration was the hallmark of early New Bedford's Quaker heritage and these attitudes helped foster cultural diversity throughout the eighteenth and nineteenth centuries, making New Bedford a city with extensive abolitionist ties and a stop on the Underground Railroad.

As whaling declined, New Bedford's emerging textile industry continued to draw thousands of immigrants from Canada and Europe. These new residents built bustling neighborhoods from the far North End to Clark's Cove in the South End. Their work ethic was the driving force behind some of the legendary names of the textile industry including Wamsutta Mills and Bershire-Hathaway.

The second half of the twentieth century has been less kind to the fortunes of this fine city, as it has to all cities in the Northeast that relied heavily on manufacturing as their economic mainstay. But New Bedford's people have always been a tenacious and hard-working lot.

As our city stands at the threshold of a new millennium, it is poised for significant growth. New Bedford's connection to the sea will continue to provide it with opportunities for growth in marine science and technology, in partnership with higher education and in maritime industry and commerce. Our rich history is now celebrated in the New Bedford Whaling National Historical Park. A host of projects are underway to improve our intermodal transportation systems to ensure a new era of prosperity.

During this sesquicentennial year, we celebrate our city's past and look forward to the future. New Bedford's prospects are indeed bright, because of its geography, its history, and most of all, its diverse and resilient people. In 1897, our semi-centennial year, Thomas B. Reed, Speaker of the National House, said of New Bedford's people: "The earth has got to be very shifty to get out of the grasp of a people equally at home on land and water." Reed's statement is no less true today.

The pages that follow are a testament to New Bedford's rich history and to its thriving cultural diversity. Paul Buchanan's insightful text aptly articulates that New Bedford's strength is and has always been its people. The rare and wonderful photographs included in this book, some never before published, are from the Special Collection Archives of the New Bedford Free Public Library. May the reader celebrate with us New Bedford's past and hail us as we chart our course for the twenty-first century.

Rosemary S. Tierney
Mayor

Introduction

No history of New Bedford could be written without a mention of Bartholomew Gosnold as the first European to touch the rich and beautiful wilderness that was to become the thriving, bustling city of today.

It was exactly fifty years after his explorations that land in the area was purchased by white men. The illustrious names of many of these men we know still today—Myles Standish, Manasseh Kempton, John Cooke, John Howland, John Alden, and William Bradford. They came from Plymouth Colony seeking a freedom from the oppressive life of the Puritans. Most of those who came were Quakers and Baptists and not inclined to settle close together around a meetinghouse. Rather, they settled apart from each other, on sites often separated by the many rivers of the area, and lived independently.

Shortly after the dawn of the eighteenth century Joseph Russell bought land from Manasseh Kempton and settled into farming. It was here that Joseph Russell III, later known as the founder of Bedford, was born. By 1750 he was laying out streets for the village. To this developing hamlet came men with skills in shipbuilding who gave birth to a new industry. In 1765, when Joseph Rotch sailed across the bay from Nantucket, he brought with him the skills and knowledge of the whaling industry, as well as the associated commercial skills of selling the oil and the making of candles.

By the Revolutionary War the Quaker values were dominant in the town and the citizens refused to participate in the fighting and privateering. Despite this, British forces landed on the night of September 5, 1778, and burned the entire business district, including ships, wharves, and the associated buildings. No ship sailed from Bedford for another seven years, the destruction was so devastating.

In 1787 the rebirth of the village was under way and the villagers successfully petitioned to become a separate town with "New" added to the name.

The second decade of the century brought the age of prosperity of whaling. By 1830 New Bedford was a larger whaling port than Nantucket, and by 1857 it could boast of a fleet of 329 ships and more than 10,000 men employed in the industry. The decline of the source of this wealth set in gradually, caused by fleets trapped in the Arctic, severe storms of destruction, and the discovery of oil in Pennsylvania in 1859.

Abraham H. Howland was elected the first mayor of the city of New Bedford after a new charter granting city status was received on March 18, 1847. Following his leadership, the people turned from the sea to develop mills and factories, which generated an even greater wealth than had been seen before. During the same year, the Wamsutta Mills was incorporated and production of shirting began in 1849. By 1883 Wamsutta was annually producing 23 million yards of cloth. Other companies quickly followed so that by late in the century there were more than fifty mills flourishing in the massive buildings.

Other industries also came. Copper and brass foundries, iron works, shoe factories, and machine shops all contributed to a vital, growing economy. New kinds of products reflected the new level of lifestyle—the Pairpoint Manufacturing Company and the Mount Washington Glass Company produced art specialties in glass and silver.

Economic well-being rode into the twentieth century. The economy flourished until, as in so much of America, the labor problems of the late 1920s were followed by the Great Depression. Most of the industries did not survive.

Today, New Bedford is continuing to exhibit the ability to adapt and adjust. Diversified industries are once again growing. Also, as more people have become aware of the rich history of the area, tourism has developed. It is anticipated that with the establishment of the National Park, New Bedford will once again see a thriving economy, this time assisted by tourism.

Throughout its history the richest asset of New Bedford has been the diversity of its people. Since its settling people have been welcomed to the area because of the skills and abilities they brought with them. As a result, as whaling grew larger and men sailed further, the men in the prows of the whale boats contesting with 50-ton whales were mostly African or West Indian—and their 8-foot harpoons had iron toggle tips invented by Lewis Temple, a native Virginian of African heritage.

By 1785 no slaves resided in the town and through the efforts of Paul Cuffe, a black Quaker of New Bedford, the state government decreed that taxpayers, irrespective of color, had the right to vote. It was in New Bedford that the great abolitionist, Frederick Douglass, became a free man.

People came from many places to New Bedford to seek a fuller life. Ireland, France, Greece, Poland, and Norway sent sons and daughters to enrich the life here. The Portuguese, including the Cape Verdeans, Madereans, and Azoreans, brought their skills, their pride, and their Catholic faith. In 1871 they experienced a fulfillment with the establishment of the first Portuguese church in the United States—Saint John the Baptist. Each of the ethnic groups came and built churches which today make a walk in New Bedford a study in the ways they have enriched the life of the city with their culture and their caring.

They have made New Bedford what it is.

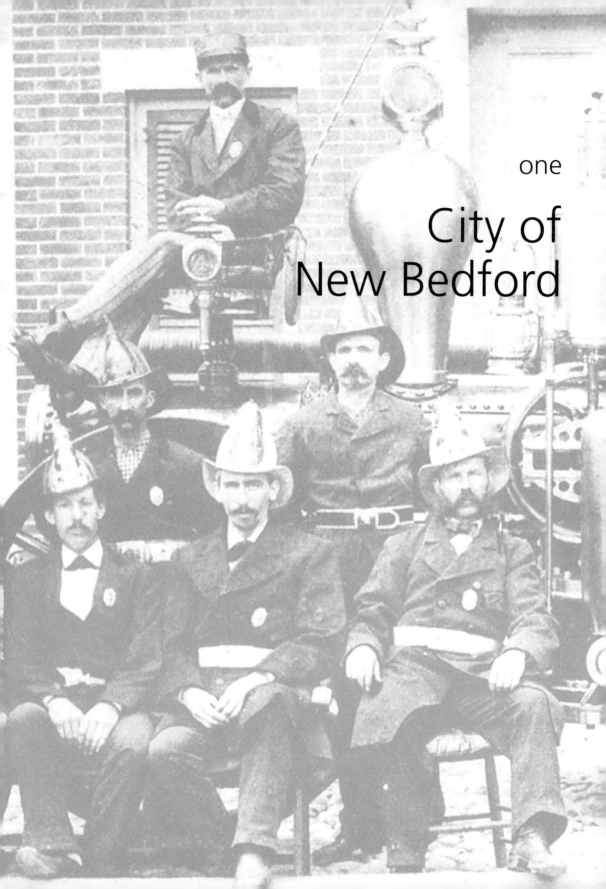

one

City of New Bedford

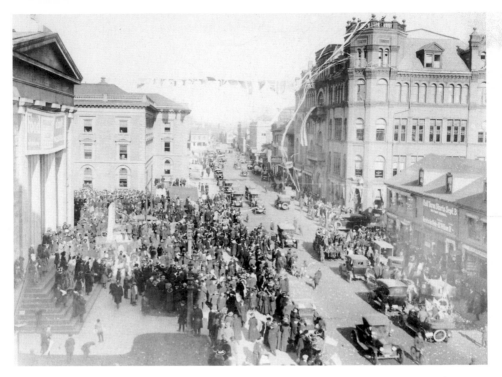

The citizens of New Bedford congregate in front of City Hall on Armistice Day, November 11, 1918. With flying flags and streamers floating in the wind, the end of World War I was celebrated with great excitement in New Bedford.

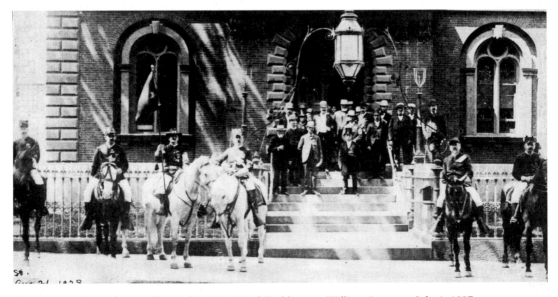

Among those shown here in front of the Municipal Building on William Street on July 4, 1887, are Charles Ashley, H.W. Kenyon, Major W.B. Topham, Chief of Staff L. Bartel, and F.W. Oesting. Those standing on the steps include G. Pickens, S.H. Faunce, W.A. Church, J.W. Kane, Mayor Morgan Rotch, S. Hawes, E.R. Leverett, Emerson Smith, J. Matthews, and B.F. Hathaway Jr.

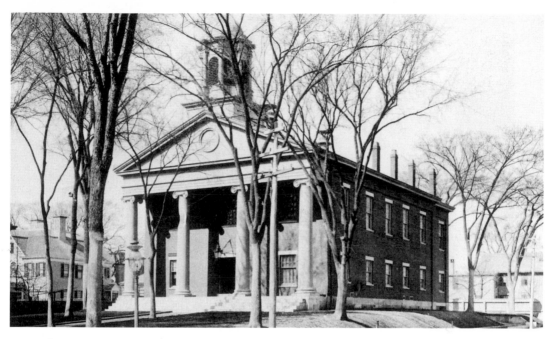

The New Bedford Court House was a Greek Revival building with Ionic columns supporting a pediment.

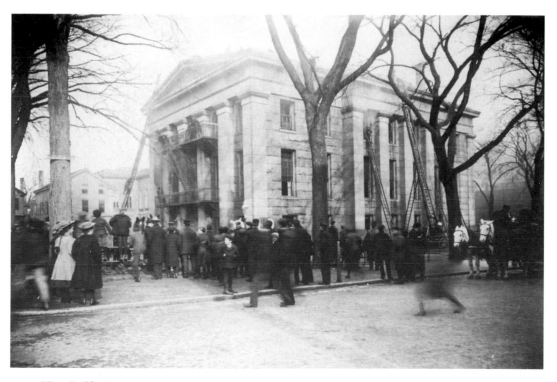

New Bedford City Hall was photographed in December of 1906 as fire erupted from the windows of the upper floors.

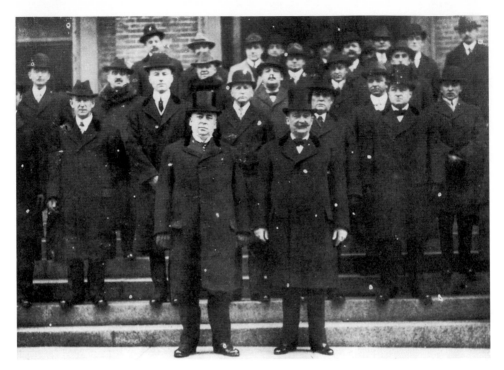

Mayor Charles S. Ashley, on the right in the silk top hat, was inaugurated as mayor of New Bedford on January 1, 1917, for his 18th term, having defeated Mayor Hathaway in the election by a plurality of 2,083 votes.

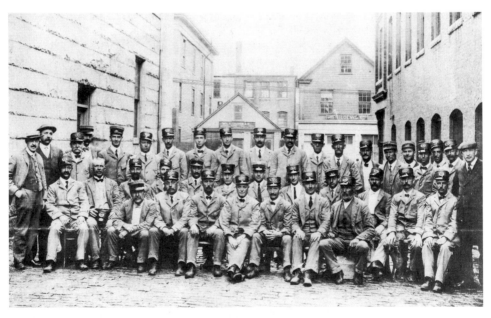

Letter carriers of the New Bedford Post Office pose for a group portrait at the turn of the century. The post office had come a long way since its opening in 1794; the penny post was instituted in 1832 with an additional penny for home delivery.

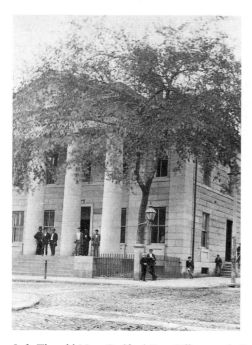 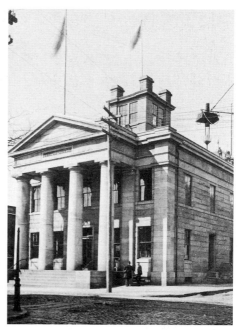

Left: The old New Bedford Post Office was built between 1834 and 1836 at the corner of William and Second Streets. Designed by Robert Mills, a noted architect, it is a substantial Greek Revival building with an impressive columned portico. After a new post office was built, this building became the New Bedford Custom House.

Right: The New Bedford Custom House was housed in the former post office at the corner of William and Second Streets. Masters of ships docking in New Bedford were required to report to the officer on duty and present a manifest of their cargo.

Members of the New Bedford Post Office stand on the side of the building in 1875. Included in the photograph are Postmaster Thomas Coggeshall, Assistant Postmaster Alfred Wilson, clerks Charles Lobdel, Silas Taber, John Gilbert, William Wilson, and Ella Nye, collector James Denham, and carriers Charles Paine, William Carney, Alexander Hillman, James Tripp, William Dunham, and A.D. Swift.

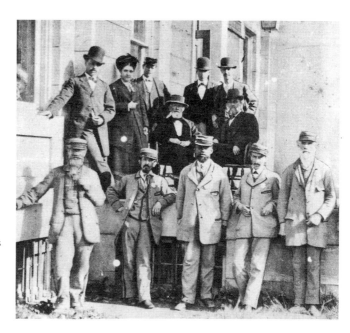

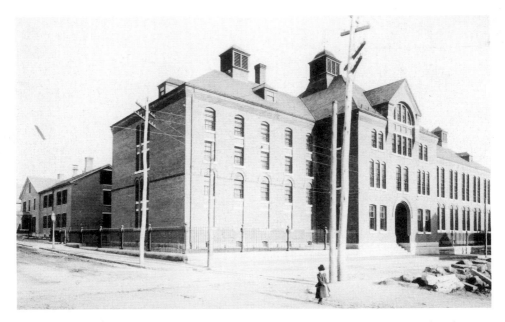

The New Bedford Jail seemed an enormous Romanesque Revival building compared to the young girl standing in the foreground.

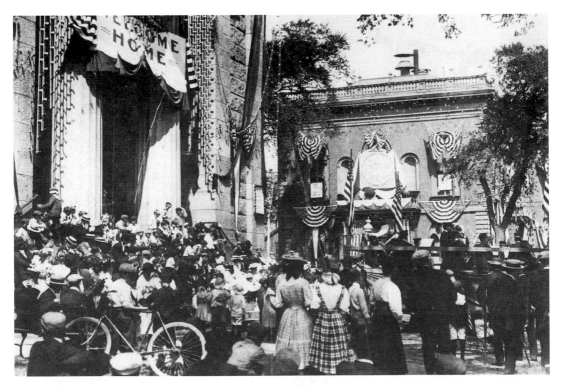

During Old Home Week in 1907, citizens, both former and present, visited New Bedford sites. Some of the participants are shown here listening to a band concert in front of City Hall. Such concerts often made feet "tap time."

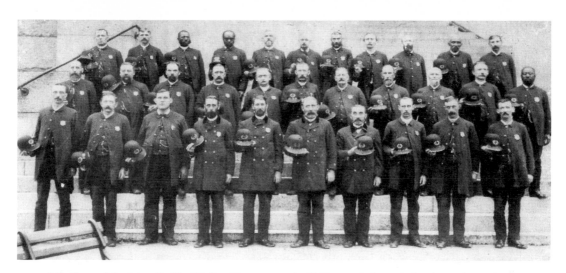

Members of the New Bedford Police Department in 1887 pose, helmets in hand, on the steps of the station. From left to right are: (front row) Arthur Jones, Washington Eldridge, John Rooks, Lieutenant Thomas Comstock, Lieutenant Seth Bryant, Deputy Chief James Wilbur, Lieutenant Ellery Pierce, Chief Timothy Allen, Milton Brownell, and William Clark; (back row) George Gendron, Lieutenant Thomas Fay, Louis Moore, Morton Yancey, Patrick Kennedy, Elisha Russell, Crawford Pierce, Jeremiah Daley, Patrick Canavan, Allen Lee, and Cornelius Murphy. Included in the middle row are John Savage, John Brady, James Mitchell, Henry Stevens, George Page, and John Williams.

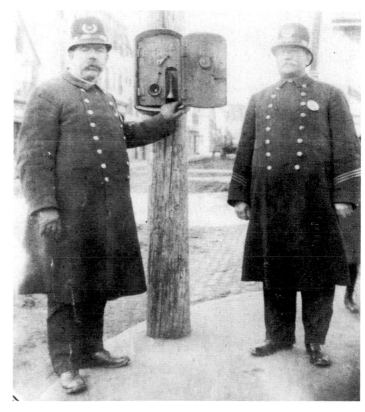

Standing at a call box about 1900 are Patrolman Arod Holloway (left) and Patrolman Thomas Dahoney. A chief of police had been appointed in 1876; at that time there were twenty-six policemen and eighty-three special officers.

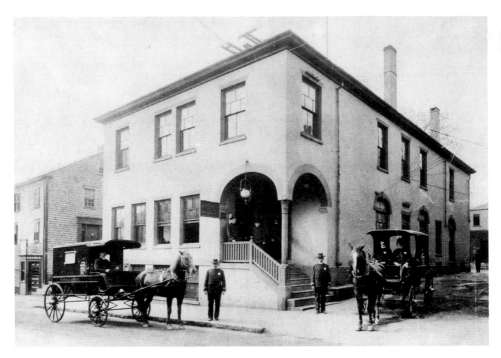

The New Bedford Police headquarters was on South Street. Standing at the foot of the steps is Thomas J. Taft, former chief of police.

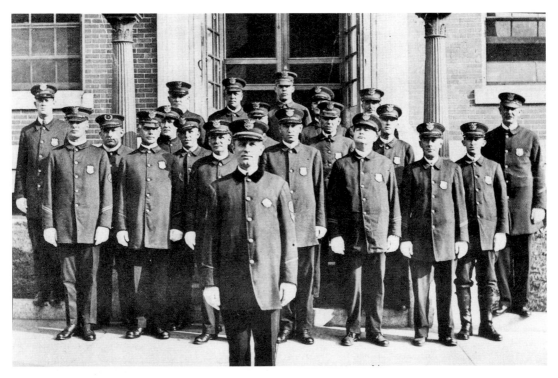

Sergeant Ivar Nelson headed the traffic squad of the New Bedford Police Department.

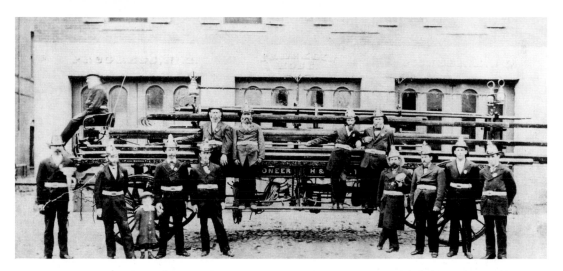

"Pioneer" Hook and Ladder Company No. 1 was photographed outside the old central engine house on Purchase Street, at Mechanics Lane. Louis Allen is in the driver's seat, and from the left are Nat Caswell, Charles Pierce, Franklin Hathaway (with his son Edward), Thomas Halloran, Thomas Manley, Charles Johnson, Abe Luscombe, John Austin, John Judson, Philip Tripp, Squire Gifford, and Benjamin Hinckley.

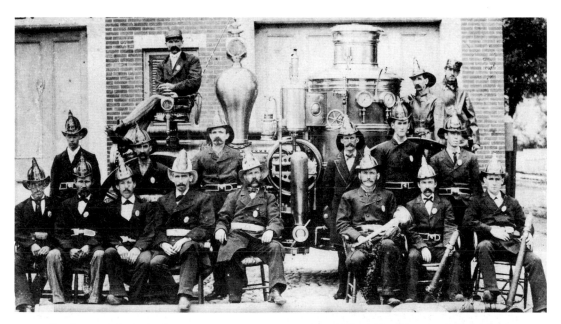

The firemen of Howland Station No. 4 in 1880 were, from left to right: (front row) Alonzo Jason, James Tripp, William Gibbs, Augustus Wood, Chief Frederick Macy, James Wing, Henry Gray, and Frank Wood; (middle row) Charles Lemunyon, James Murdock, Hugh McDonald, Charles Carr, Charles Wing, and Edgar Gilbert; (back row) George Tripp, Daniel Briggs, and Richard Taber.

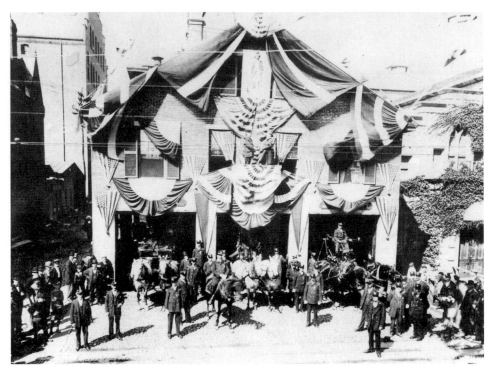

Participating in the New England Fire Muster on August 12, 1897, were Captain L.T. Parlow (on horseback) and Captain John Downey, Captain David Howland, Captain Edward Frances, Frederick Mosher, Charles Allen, Charles Vinning, C.P. Johnson, C.H. Johnson, George Allen, Benjamin Groves, Charles Robertson, Edward Neagus, William Durfee, George Taylor, John Thompson, William Fletcher, Louis Mosher, Alfred Gifford, and John Baker.

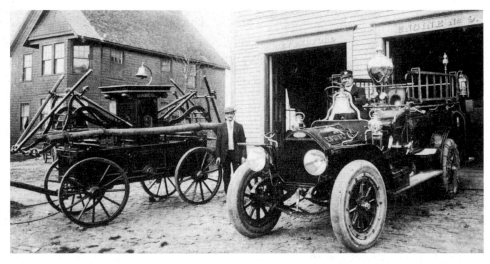

John Parker (left) is standing with a "hand pumper" while Philip Prevost sits aboard a new motor-driven firetruck in 1910 at Station No. 9 at Lund's Corner. Hand pumpers were filled with water from fire buckets and then pumped by firemen to create a suction so that water could be directed at the fire.

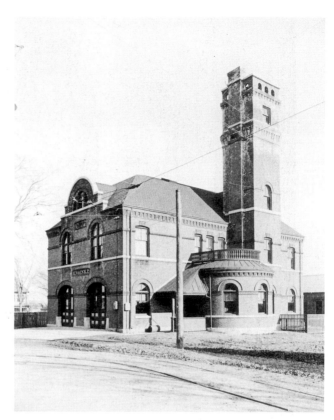

Engine House No. 7 was an impressive brick Romanesque Revival firehouse with a soaring tower that was a far cry from the earlier firehouses.

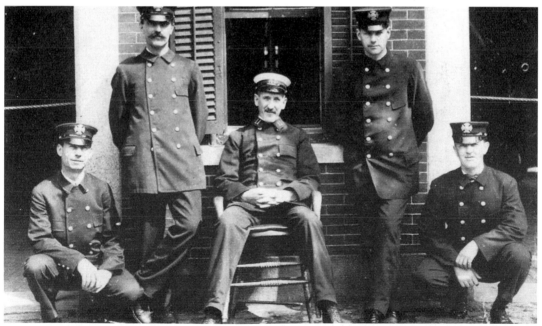

Posing *c.* 1905 outside of Engine No. 4 of the New Bedford Fire Department are, from left to right, William Durfee, Mr. Dyer, Captain Charles Wing, James Wing, and Walter Merchant.

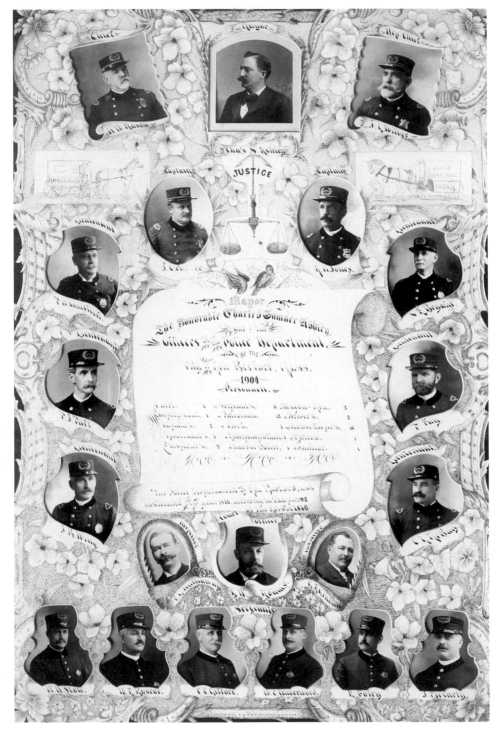

Officers of the New Bedford Police Department are pictured here on a 1904 broadside that included Mayor Charles Ashley, whose portrait is flanked by Chief H.W. Mason and Deputy Chief J.L. Miller.

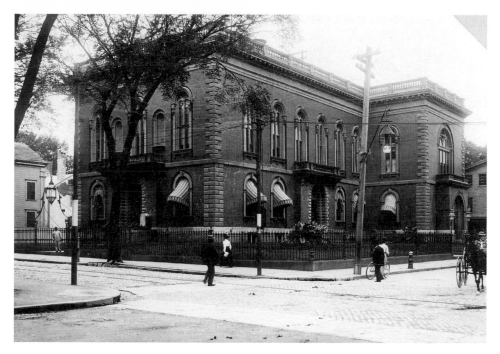

The old City Hall gave way to the New Bedford Free Public Library in 1910, and the collection was greatly enlarged by librarian George H. Tripp; the library was the first ever established, supported, and managed by any city, absolutely free to all the people.

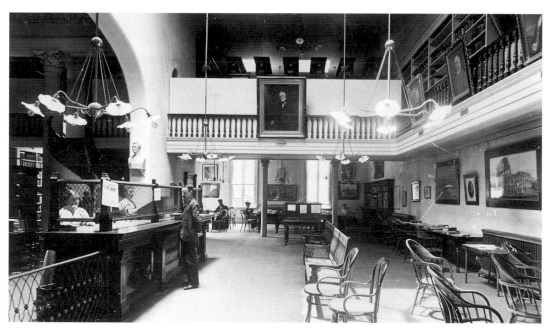

Dr. Edward Tucker, standing in the reading room of the New Bedford Free Public Library, is speaking to librarians Florence Farwell and Josephine Merrick, who are shielded by a wire grate.

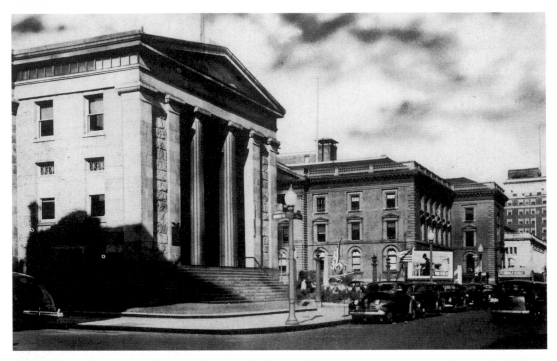

In a photograph of Pleasant Street about 1940, the New Bedford Free Library is on the left, with the Municipal Building, New Bedford Post Office, and the New Bedford Hotel on the right.

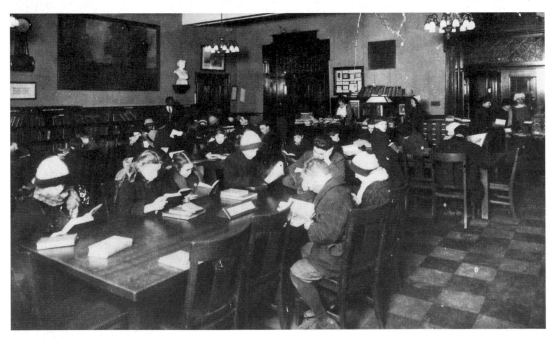

Perhaps no room in the New Bedford Free Public Library experiences as much activity and constant use as the children's room, facing Market Street. The children study intently, and quietly, following a long school day.

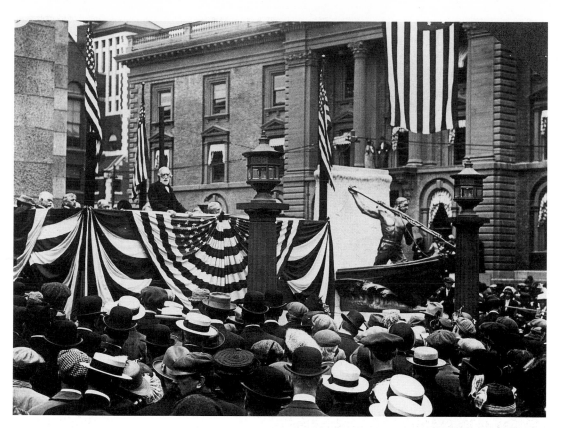

Above: William Wallace Crapo addresses the audience from a flag-bedecked podium at the dedication of the Whaleman's Statue in front of the New Bedford Free Public Library.

Right: The Whaleman's Statue, sculpted by Bela Pratt, commemorates the heroism of the men of New Bedford who in the nineteenth century went down to the sea to bring back whale oil that illuminated the dark. A gift of William W. Crapo, the monument is engraved with the phrase "A Dead Whale Or A Stove Boat."

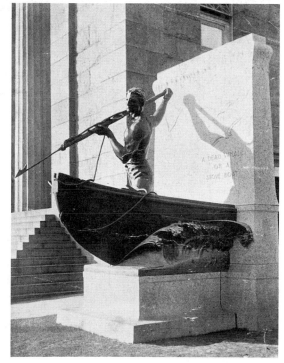

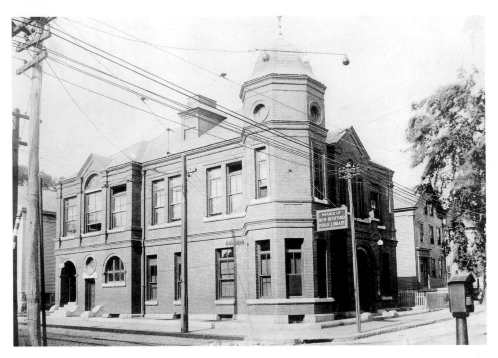

The west branch, one of three branches of the New Bedford Free Public Library, was in a fanciful paneled brick structure.

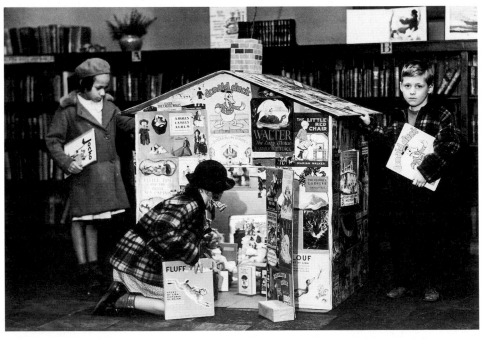

During November 1937, National Children's Book Week was observed at the library. The child on the left remains unidentified, but Patricia Clavin is in the center looking at the display, and Carroll Peter Clavin is on the right.

two

The Streets of
New Bedford

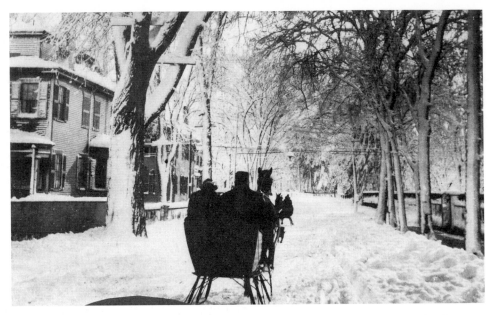

At the turn of the century, a horse-drawn pung travels down County Street, just north of Union Street. The snow-covered trees added lustre and sparkling light, and the "rolled" snow in the street was conducive to sledding in winter months.

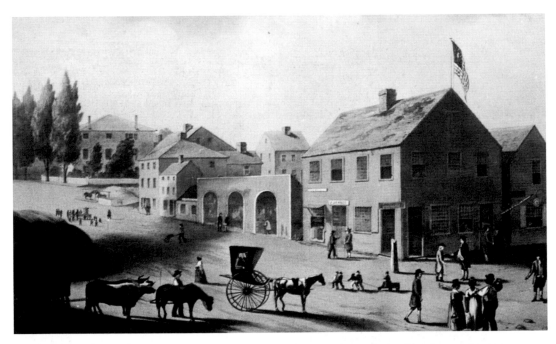

Old Four Corners was the junction of Union and Water Streets and was depicted by the noted artist William Wall as it appeared in 1807. This bucolic setting of "Johnnycake Hill" shows the William Rotch Sr. house behind the poplar trees, with Rotch in the chaise in the foreground. Also in the painting are Peter Barney, Jehaziel Jenney, Abraham Russell, William Rotch Jr., Nathaniel Rogers, Samuel Rodman, and Captain Rowland Crocker.

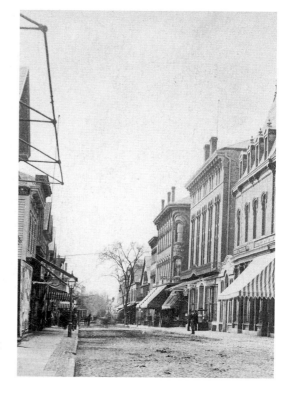

Right: Purchase Street, in a view looking south, had the New Bedford Five Cents Savings Bank on the right.

Below left: Scenes like this one on Purchase Street were common in mid-nineteenth-century New Bedford. A group of residents stand in front of Sherman & Company, a purveyor of sextants.

Below right: Store clerks stand in their doorways along Purchase Street as awnings were unrolled during the hot summer afternoons.

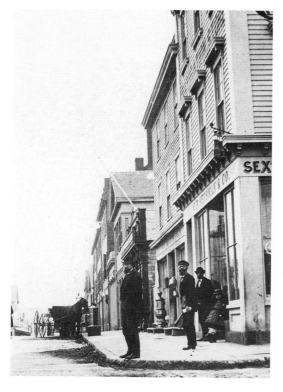

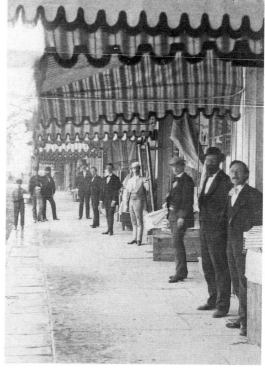

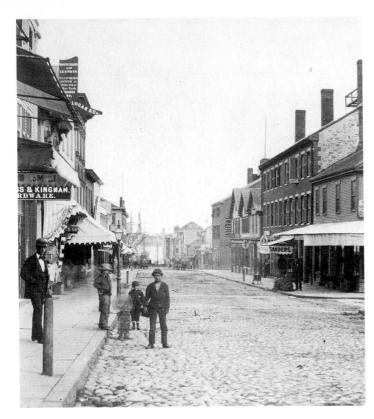

Left: Union Street, looking east, had small shops on both sides of the street. Notice the street paved in cobblestones.

Below: Union Street, looking toward the harbor in the late 1880s, had telegraph wires, mounted on poles, descending to the water where a ship lies at dock.

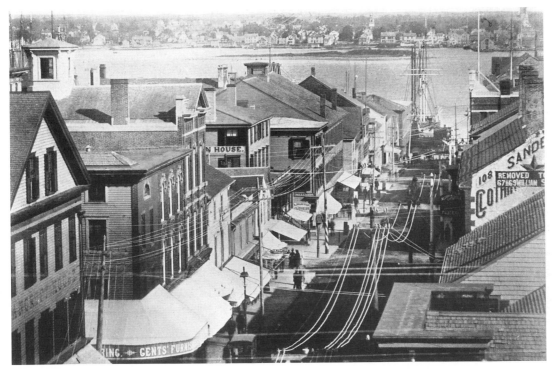

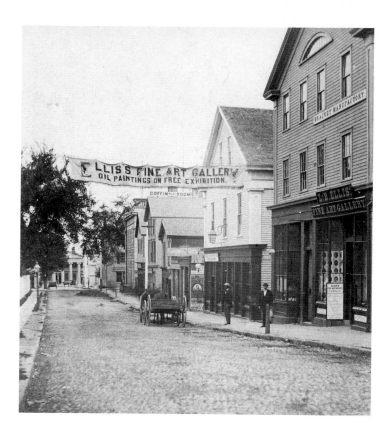

Right: William Street, *c.* 1870, had Ellis' Fine Art Gallery on the right, and a banner spanning the street that encouraged visitors to see the "oil paintings on free exhibition."

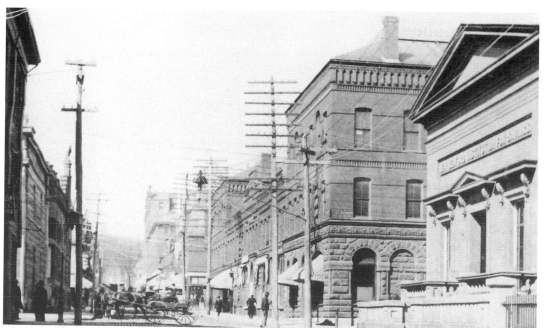

William Street, at the turn of the century, was a bustling center of commerce. On the right is the New Bedford Institution for Savings.

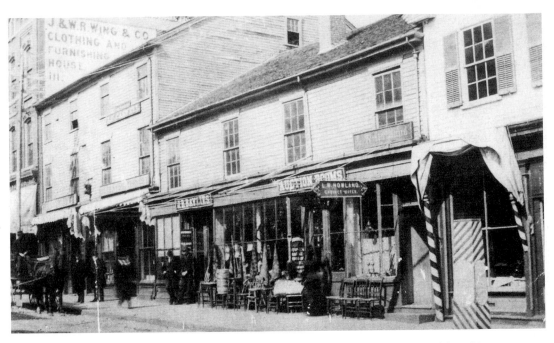

On Union Street, below Acushnet Avenue, was the J. & W.R. Wing clothing and furnishing house; J.B. Baylies' auction rooms; and Lysander W. Howland's cabinet-making shop.

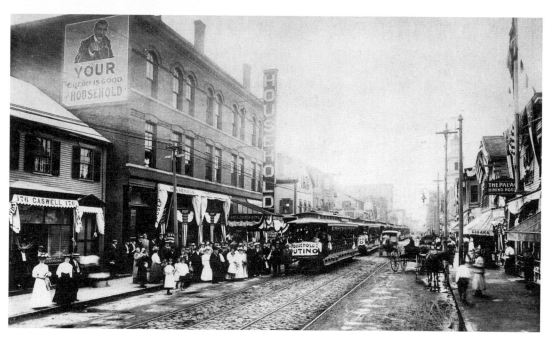

Household's Outing had a workers' holiday with a large number of streetcars pulled up in front of the store, soon to transport employees to the country for a picnic.

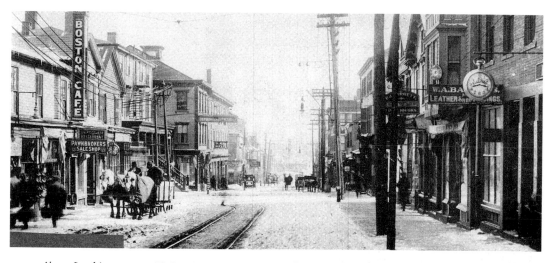

Above: Looking east on Union Street, numerous small shops lined both sides of the street. Notice the number of "advertising signs" such as clocks, gilded balls, and the three balls of the pawnbroker.

Opposite below: Shown here in 1892, at the corner of Potomska and South Second Streets, are the following: William Johnson, Joseph Fernandes, Mrs. Minnie Fernandes, Herbert Lamphier, Thomas Regan, Frank Murphy, Steve Cassidy, Mike Mitchell, George Alexander, Manuel Andrews, Frank Cunha, Abram Sutton, Jack Livingstone, Fred Griffin, Charlie Murphy, John Jesse, and Mrs. Abram Sutton. At the corner in a hat is "Big" Jack Frazier, and seated on the wagon are Joseph and George Fernandes.

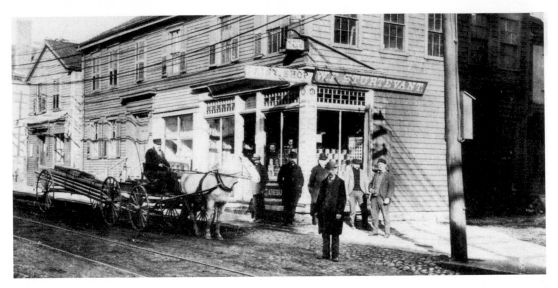

W.F. Sturtevant had a paint shop at 41 Middle Street, between Water and Front Streets.

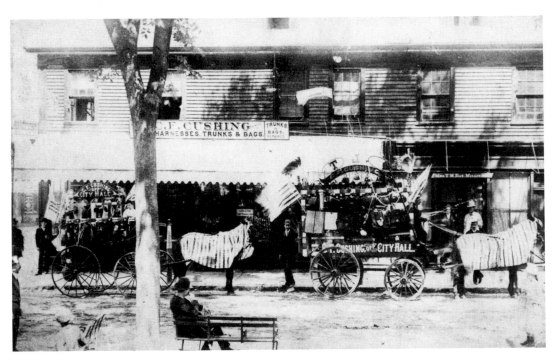

Above: C.F. Cushing was a purveyor of harnesses, trunks, and bags at the corner of William and Pleasant Streets. Horses pull tinker wagons in front of the store.

Opposite below: A dapper "Cheap John" leans on a statue of Punch which stood in front of his store on Purchase Street for years. "Cheap John" was a Brazilian, whose actual name was John Cunha, who owned a tobacco and sporting goods store as well as a billiard parlor.

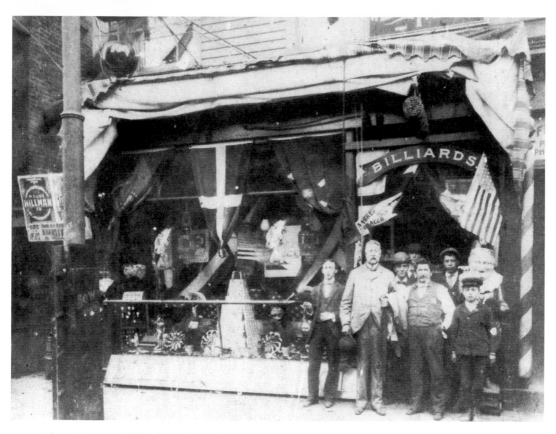

Above: A group of friends stands in the door of Cheap John's Place. "Cheap John" stands with a vest next to Rear Admiral George Winslow outside the shop *c.* 1900.

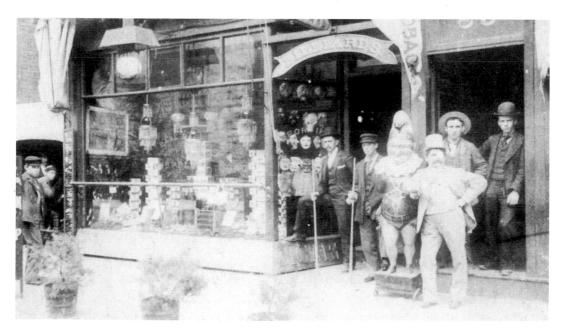

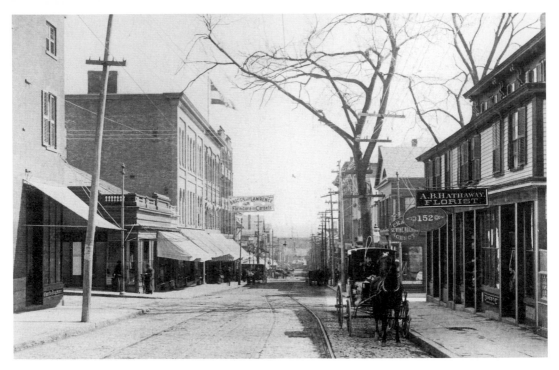

Union Street in the late nineteenth century had streetcar tracks running down its center and numerous businesses on either side. A carriage has pulled up in front of Hathaway's Florist Shop.

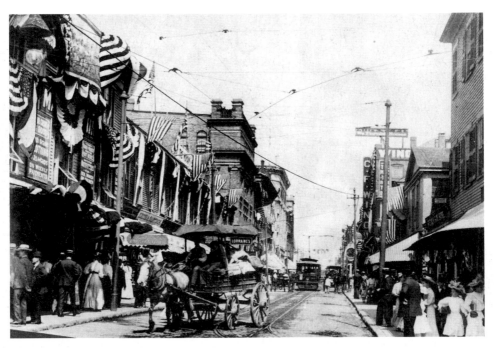

During Old Home Week in 1907, Purchase Street was bedecked with flags and bunting to welcome visitors to New Bedford.

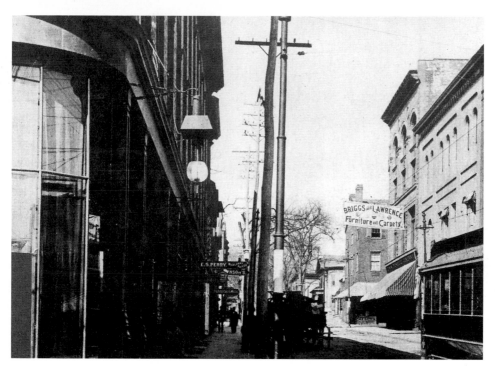

In this 1890 view looking west at the corner of Union and Purchase Streets, one can see a streetcar passing on the right.

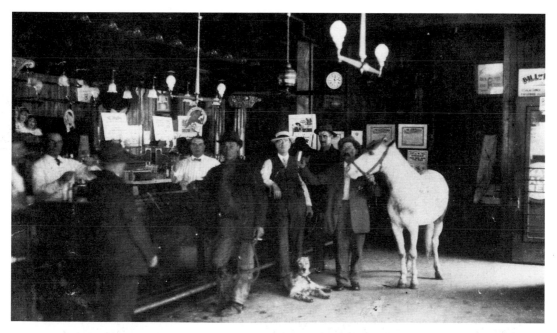

Denny Shay's Barroom was at the corner of Elm Street and Acushnet Avenue. John Bohan and Fred Ling are standing behind the bar, while Joe Barbosa, Denny Shay, and Israel Sher lean on the bar and Mr. Sher holds the pony's reins. Obviously, Shay's served all sorts of customers!

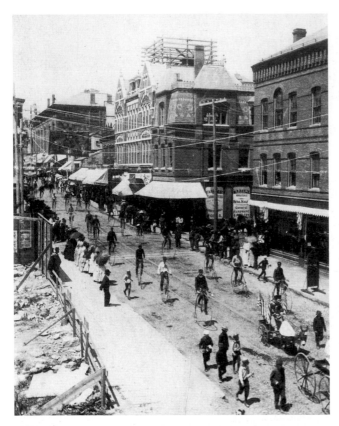

Left: The High Seaters Bicycle Parade was held on July 4, 1888. Looking west on William Street toward Acushnet Avenue, one could see the post office being built.

Below: Posing in the Boston Beef Market in Ashley Arcade on Aucushnet Avenue are Thomas Smith, James Hughes, and John T. Smith (all behind the display case), proprietor W.S. Gordon (center), and Elsie Cunningham (on the right).

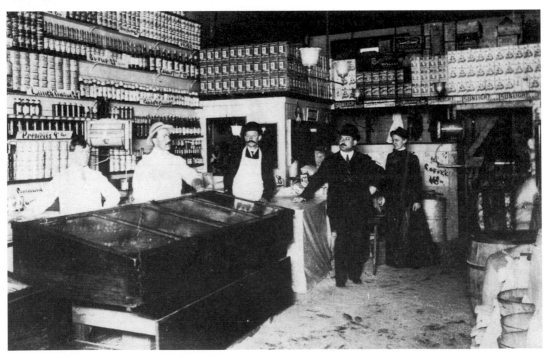

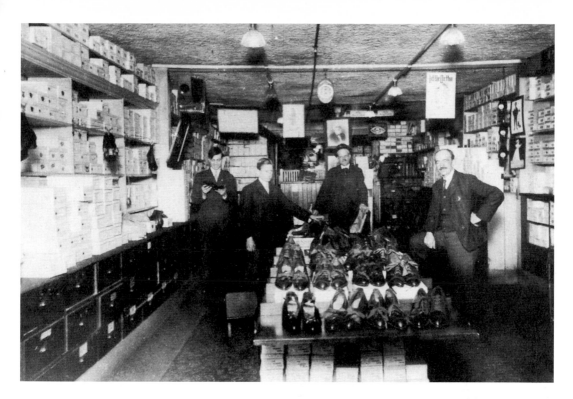

Above: The Pardon Devoll and Sons shop, founded in 1839, was located on Purchase Street. Shown here selling shoes are, from left to right, John R. Perry, William Winsper, proprietor Dan Devoll, and shop manager T.F. O'Hara.

Right: Allen's Theatre was one of New Bedford's leading motion picture, and illustrated song, houses. A group of people stands in front of the theatre entrance in 1919.

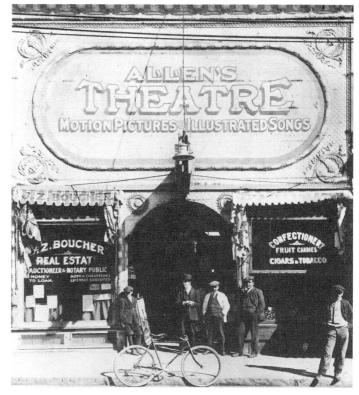

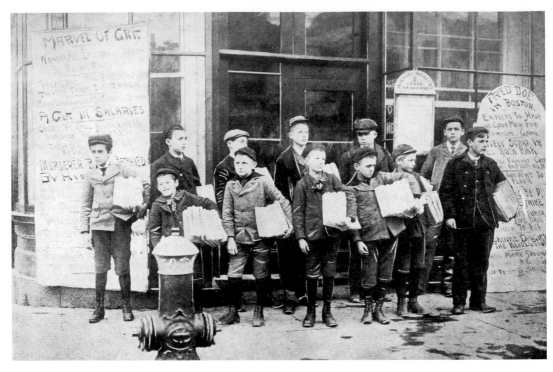

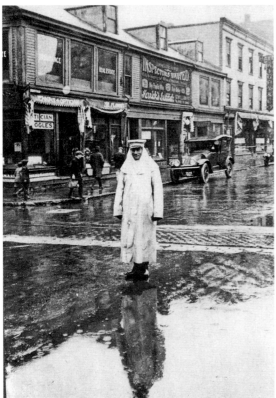

Above: A group of newspaper boys stands ready to sell the *New Bedford Morning Mercury* at the turn of the century. These boys went forth in all sorts of weather to distribute the news.

Left: Traffic Sergeant Ivar Nelson stands in a yellow slicker in the middle of the intersection of William and Pleasant Streets *c.* 1915. Though wet, he had a ready smile for the cameraman.

three

Places of Worship

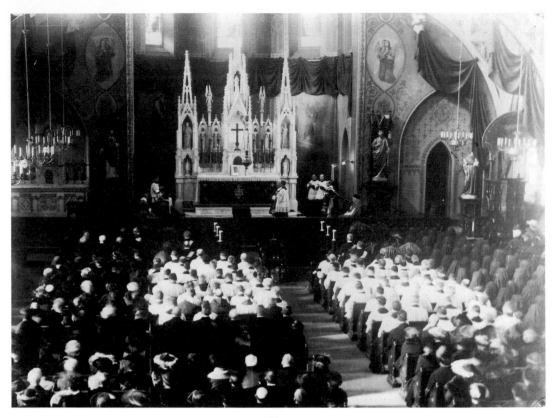

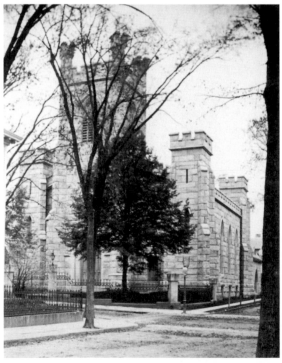

Above: Saint Lawrence Church was the scene of an elaborate funeral service for the Right Reverend Monsignor Hugh J. Smyth, rector of the church, on February 7, 1921. A magnificent altar of white marble was flanked by walls painted with beautiful renditions of angels.

Left: The First Unitarian Church was built in 1838 at the corner of Union and Eight Streets, and was designed by Alexander Jackson Davis and Russell Warren. A stone church with crenelated towers, it was an impressive Gothic Revival design.

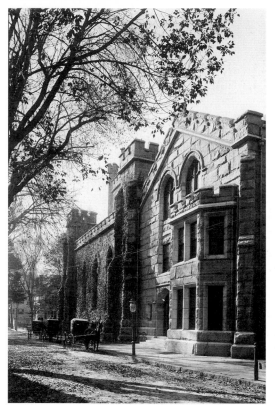

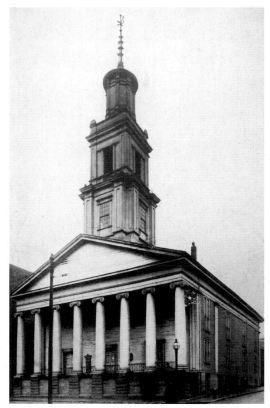

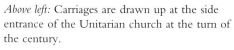
Above left: Carriages are drawn up at the side entrance of the Unitarian church at the turn of the century.

Above right: The "White Church," or the North Christian Church, stood at the corner of Purchase and Middle Streets. Built in 1833 and designed by Russell Warren, it was an impressive Greek Revival church with an Ionic colonnade and a soaring spire.

Right: Grace Episcopal Church was built in 1881 at the corner of County and School Streets on land donated by members of the Rodman family. A large Romanesque Revival church, it served a congregation that was founded in 1833.

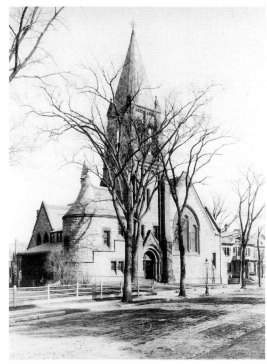

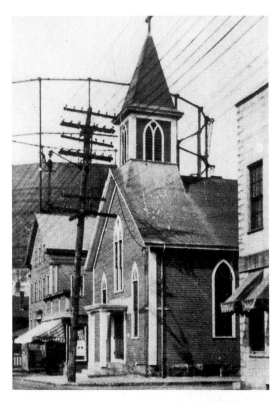

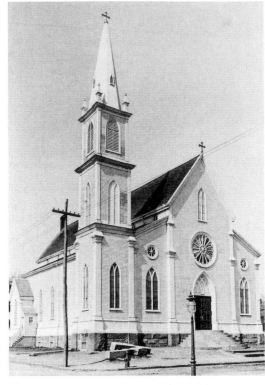

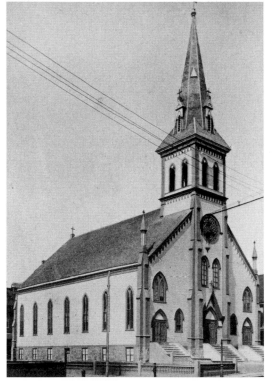

Above left: Our Lady of the Assumption Church was built at the corner of Leonard and South Water Streets for the growing Catholic population of New Bedford. Photographed at the turn of the century, it was hemmed in by a grocery store and a lumber firm.

Above right: The original church of Saint John the Baptist was founded in 1871 by Father Joao Ignacio de Azevedo. It was the first Portuguese church in the United States and it served a large Portuguese congregation. The present church was built by the congregation in 1913.

Left: The Church of the Sacred Heart was a Stick-style church built to serve the needs of that parish.

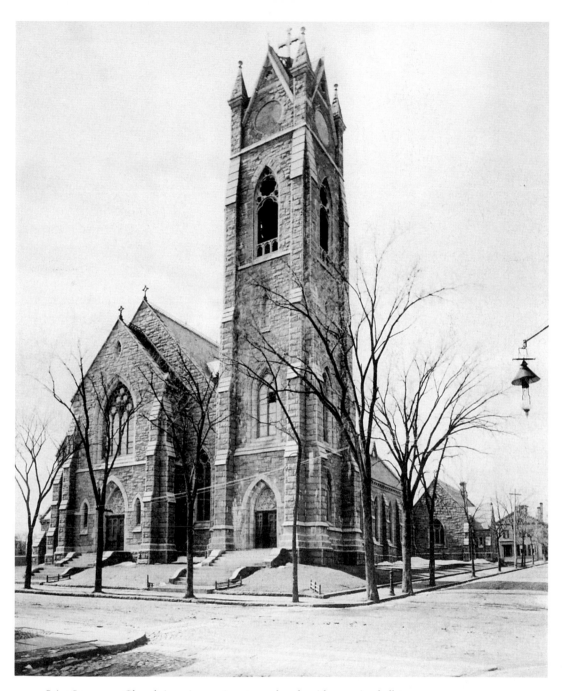

Saint Lawrence Church is an impressive stone church with a soaring bell tower.

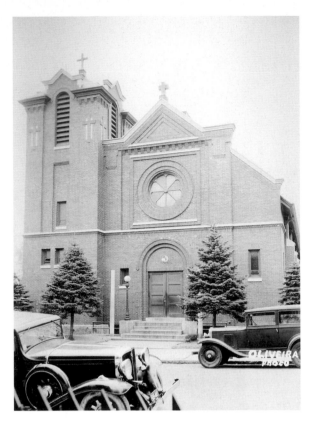

The Immaculate Conception Church (Fronteira da Ygreja de Nossa Senhora da Ymaculada Conceicao) was built as a place of worship by the Portuguese.

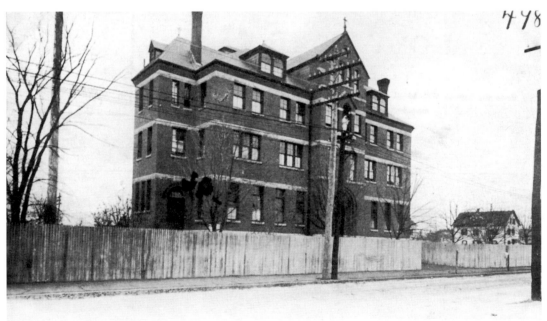

Saint Mary's Roman Catholic Home was on Kempton Street. A large brick Romanesque Revival retirement home, it provided an important service to elderly Catholics.

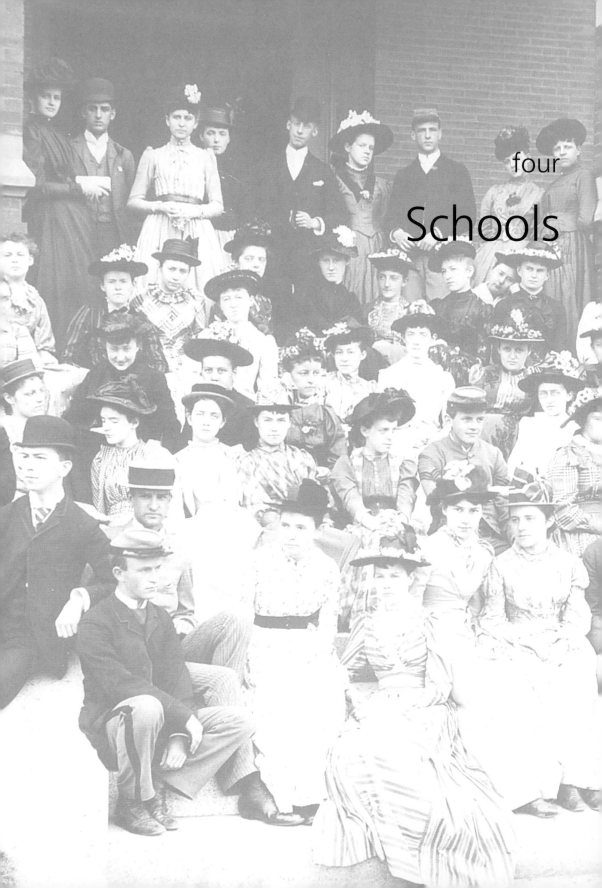

four

Schools

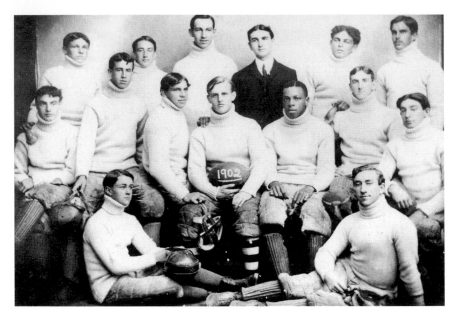

These are "The Gridsters" of 1902, the New Bedford High School football team. From left to right are: (front row) William Cobb, Lincoln Sowle, Alfred Eaton, Charles Blossom, Clarence Sykes, Clinton Davis, and Frank Neild; (middle row) William Deacon and Frank Driscoll; (back row) Lawrence Allen, Hubert Kelleher, George Lawrence, Chester Hofe, George Sistare, and Thomas Williams.

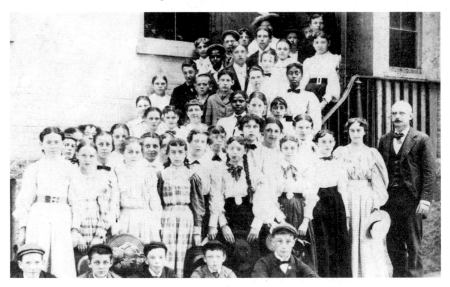

This was Graduation Day at the Middle Street Grammar School in 1896. Identifications given on the back of the photograph list the following: (on the right) principal George H. Tripp; (in the back) Miss Lucy Fish and Miss Lucy Winchester, teachers in the two senior classes; (partially visible at the very bottom) Howard Smith, Fred Swain, James Murray, William Read, and Fred Whiting. Also appearing in the photograph are Walter Wiggins, Harris Poole, Eugene Stanton, Leon Huggins, Edward Everett, Frank Habicht, Daniel McKachern, and Cranton Jennings.

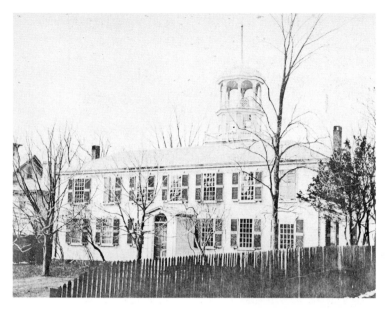

The Old Academy was founded in 1810 by Quakers in New Bedford on Bethel Street, Johnnycake Hill. The "Friend's Academy" was an impressive federal schoolhouse with a substantial belfry.

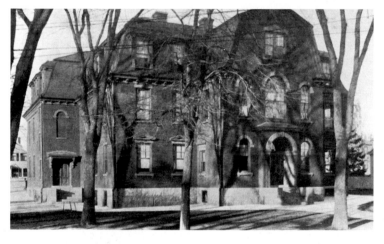

The Parker Street Grammar School was typical of schools being built in late-nineteenth-century New England cities. A brick two-story schoolhouse with a mansard roof, it could accommodate more than five hundred students.

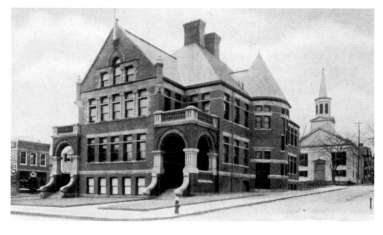

The Sylvia Ann Howland School was a brick Romanesque Revival schoolhouse with entrances on either side for boys and girls. On the right is the Second Advent Church.

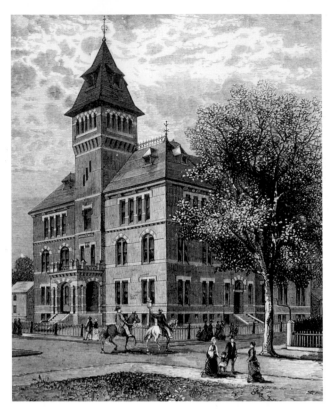

Left: The New Bedford High School was a model of efficiency and an up-to-date design when it was completed. A soaring tower punctuates the roof and polychromatic stone creates an interesting design.

Below: School cadets of the New Bedford High School pose for a photograph *c.* 1895. From left to right are: (front row) Charles F. Connor, Captain Benjamin A. Twiss, and William C. Phillips; (back row) Lieutenant Theodore Gifford, Charles Milliken, Zenas Briggs, Henry Howard, Lester Potter, Richard Bennett, and Clarence James.

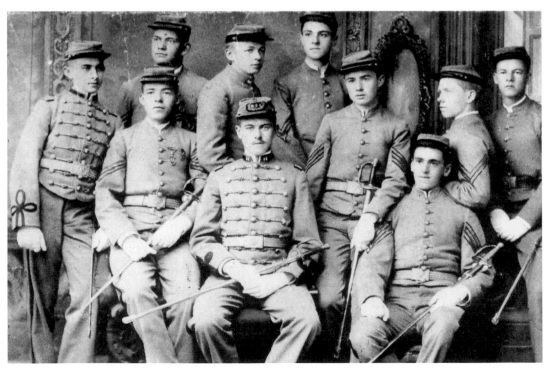

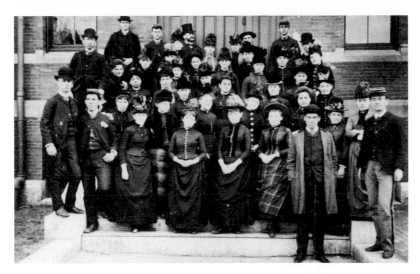

The Class of 1887 of New Bedford High School poses for its class portrait. The class included Franklin James, Ellis Howland, Frederick Greeley, Walter Channing, William Harding, James Brown, Harry Stevens, George Bonney, Fred Besse, George Gray, John Bennett, Theodore Baylies, Rachel Dunham, Lois Sowle, Nellie Stetson, Mary Pasho, May McAfee, Margaret Warfield, Grace Covell, Grace Carver, Sadie Hatch, Margaret Tucker, Kate Barstow, Lena Hamblin, Daisy Butts, Jennie Case, Anna Croacher, Katherine Duffy, Ardra Taylor, Isabelle Donaghy, Mary Dugan, Lizzie Donovan, Alice Church, Mary Hennesy, Alice Hurley, Nellie Kiernan, Myra Leach, Florence Leeming, Lila Lowe, Mary Mason, Eva Godfrey, Minnie White, Emma Whitney, Edith Weeden, Florence Vinal, Harriet Gardner, and Lillie Holmes.

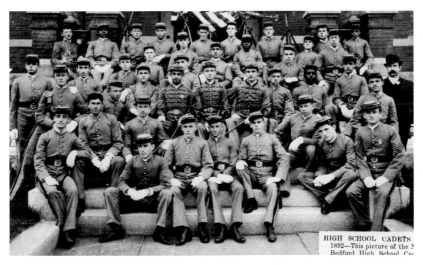

HIGH SCHOOL CADETS
1892—This picture of the N
Bedford High School Ca

New Bedford High School cadets of 1892 pose on the steps of the school. Members included Fred Graves, William Knox, William Potter, Charles Hillman, William Arnett, George Gibbs, Horace Humphrey, Walter Paige, Walter Butterfield, Andrew Greaves, Harold Bowie, Herman Hunt, Vernon Faunce, Mr. Gaynor, Ira Phillips, William McAfee, Fred Weeden, John Gammons, Lieutenant William Smith, Captain John Kelliher, Lieutenant Ernest Reed, William Travers, John Hathaway, Captain John Mc Afee (drillmaster), Everett Tripp, Percy Read, John Lee, Harry Boomer, William Chase, and Arthur McGee.

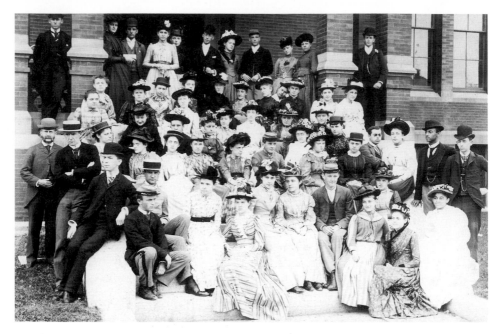

Members of the Class of 1890 of New Bedford High School pose on the steps of the school for their class portrait.

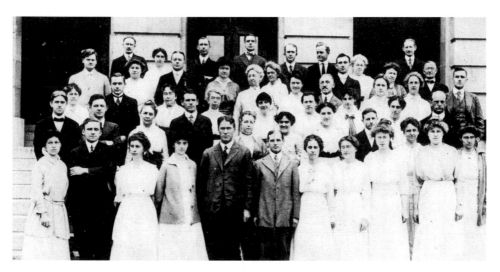

The faculty of the New Bedford High School in 1915 included Irene Nelson, Sumner Marvell, Edith Weaver, Ralph Dow, Arthur Todd, George Joffray, Cleveland Amidon, Eugene Dupin, Isabelle Browne, Marion Harrington, Harry Whittemore, Mildred Gray, Lydia Cranston, Helen Hadley, Harold Willey, Tyna Helman, John McInerney, Edmund Searls, Lucretia Smith, Genevieve Dunphy, Clarence Arey, Mary Hitch, Gertrude Cunningham, Mary Trask, Katherine Scribner, Walter Williams, Jesse Barbour, Lena Newcastle, Wilfred Baker, Helen Stedman, Wilhelmina Ernst, Winfield Kimball, Irene Belanger, Charles Bonney, Abraham Gretsch, Susan Sherman, Clara Sherman, Annie Sherman, John Card, Louis Raymond, Lydia Sargent, Mabel Cleveland, George Ferguson, Mabel Rand, Jessie Fowler, Edith Walker, Edmond Baudoin, Elsie Jenney, Allison Dorman, Frederick Kelley, and Esther Luce.

Those who made New Bedford Great

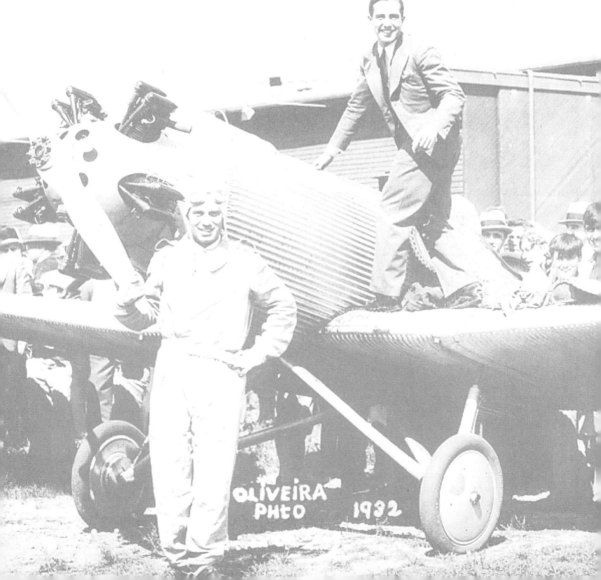

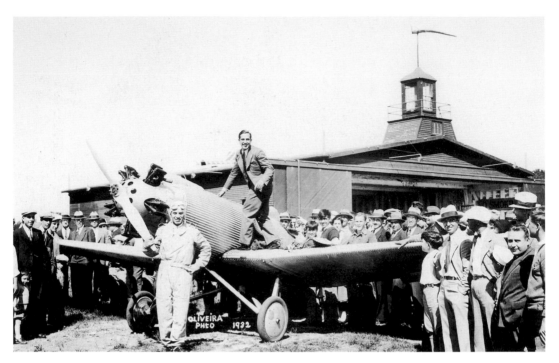

The Portuguese in New Bedford became a major part of the population by the turn of the century. Tenente Abreau, an early Portuguese aviator, stands by the propeller of his small plane at the airport in Fairhaven in 1932.

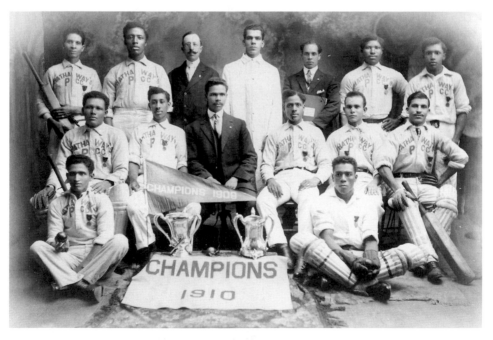

The Hathaway Mill Cricket Club members pose proudly with their silver trophies won in 1909 and 1910. These members were Cape Verdeans who came to New Bedford to work in the mills.

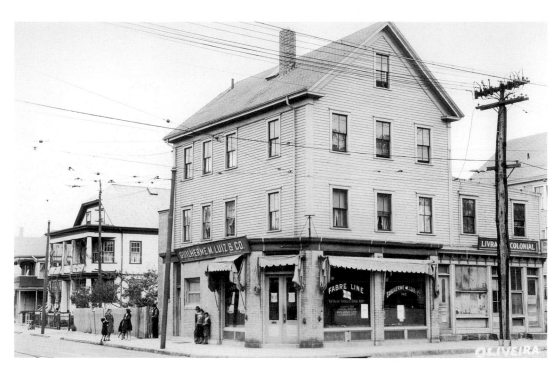

Above: Guilherme M. Luiz & Company was a small bank for the Portuguese community in New Bedford.

Right: The Portuguese residents of New Bedford supported the "Associacao Beneficente Caboverdeana," which was in a large Greek Revival building.

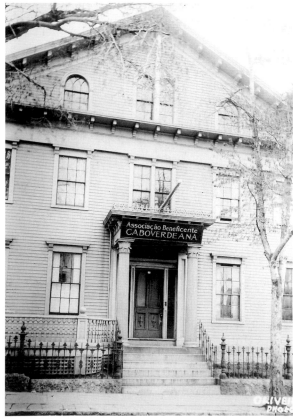

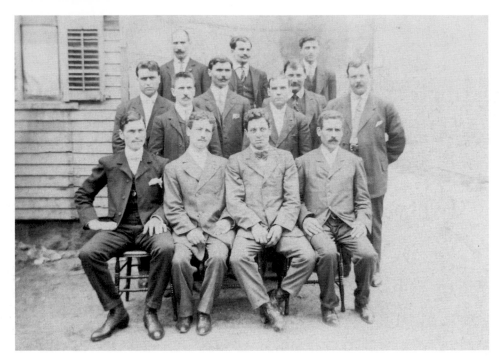

These Portuguese men posed for a photograph in 1908 to commemorate their participation in an English language course offered by the New Bedford Free Public Library.

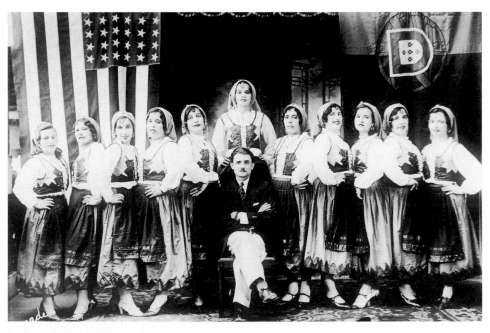

Ethnic dances were an important part of the social aspects of New Bedford's Portuguese community. The "Grupo-Foloborico-Marias de Portugal" pose in traditional Portuguese costumes in front of the American flag in the early part of the century.

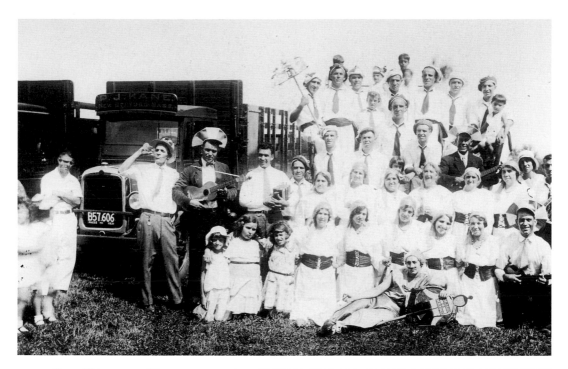

Above: This group of Portuguese posed in 1931 beside a truck from the P.J. Kane Company, probably where they were employed. The truck likely brought them into the countryside, where they enjoyed an afternoon of traditional dance.

Right: In 1932, members of the Portuguese community in New Bedford celebrated the 500th anniversary of the discovery of the Azores, as well as the 50th anniversary of the founding of the "Monte Pio Luzo Americano." The large number of people watching the parade gives an idea of how thriving the Portuguese community had become by this date.

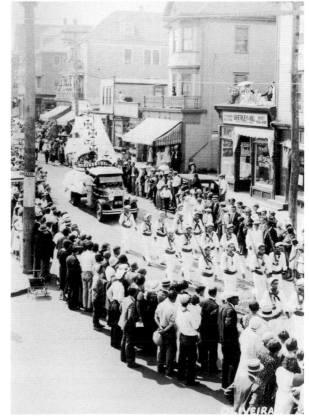

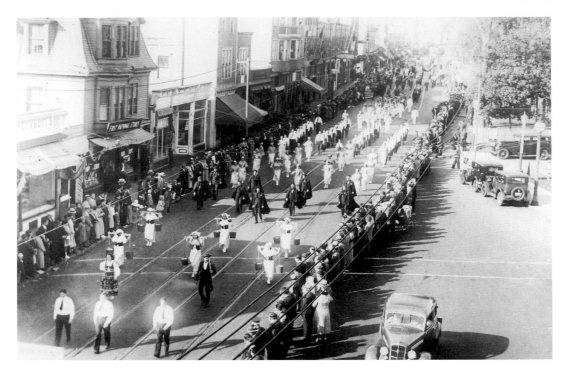

The parade brought many residents to participate in the anniversary celebration, as well as to watch the various paraders.

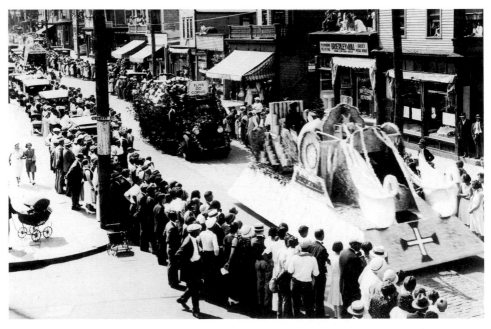

Impressive floats elicited gasps of delight as they passed the parade watchers. Notice the people standing not just along the sidewalks but watching the parade from windows, rooftops, and balconies.

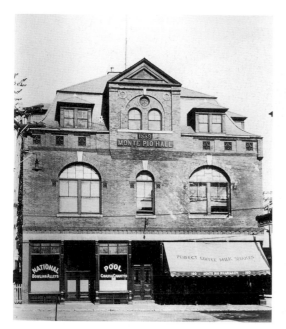 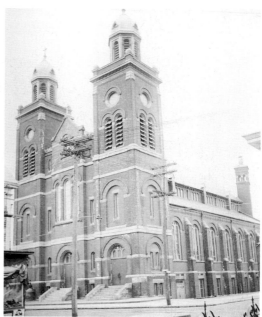

Left: Monte Pio Hall was built in 1889 by the Portuguese community. On the first floor of this brick block was the National Bowling Alleys, the pool hall, and the Monte Pio Pharmacy.

Right: The "Ygreja de Nossa Senhora do Monte Carmo" was a Portuguese Romanesque Revival church with twin towers flanking the facade.

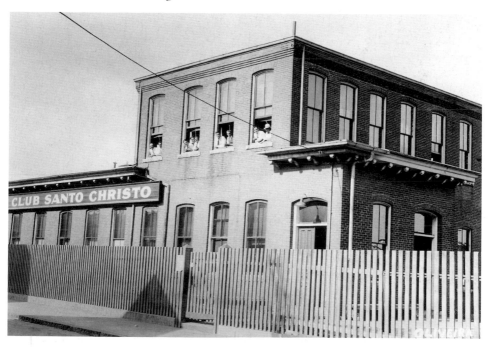

The "Club Santo Christo" had members looking out the windows when a photographer took this picture in 1932.

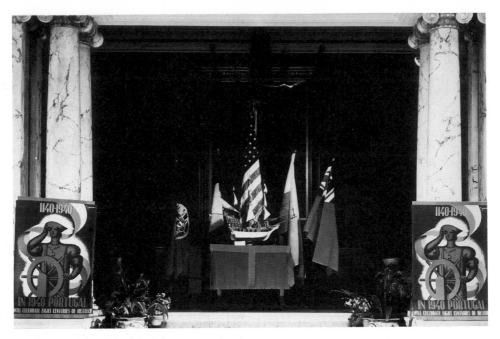

Eight centuries of Portuguese history (1140–1940) were celebrated in New Bedford at the International Exhibit in 1940.

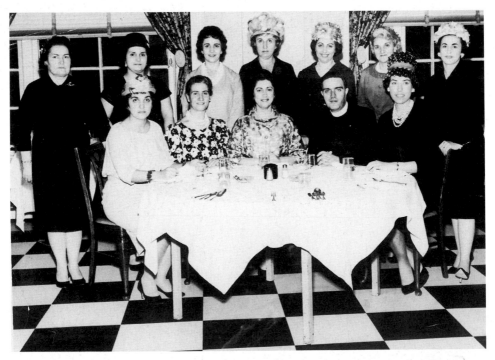

Reverend Father Constantine Bebis and members of the Greek Orthodox Ladies Philopyochios Officers pose for their photograph in the late 1950s. (Courtesy of Saint George's Greek Orthodox Church.)

Right: Bestowing his blessing on the parishioners of Saint George Greek Orthodox Church is His Eminence Archbishop Athenagoras, head of the Greek Orthodox Archdiocese of North and South America. Assisting was Father Nicholas Hatzivasiliou, pastor of Saint George's, the church for the Greek community of New Bedford. The devout stand in front of the church in 1937. (Courtesy of Saint George's Greek Orthodox Church.)

Below: Members of the All Greek Girls' Drill Team pose on the steps of Saint George's Greek Orthodox Church, with a trophy they won for their championship performance in 1937. (Courtesy of Saint George's Greek Orthodox Church.)

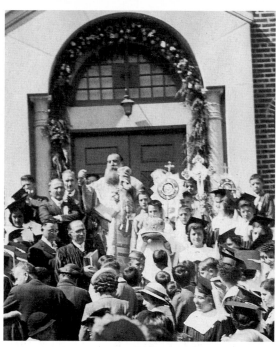

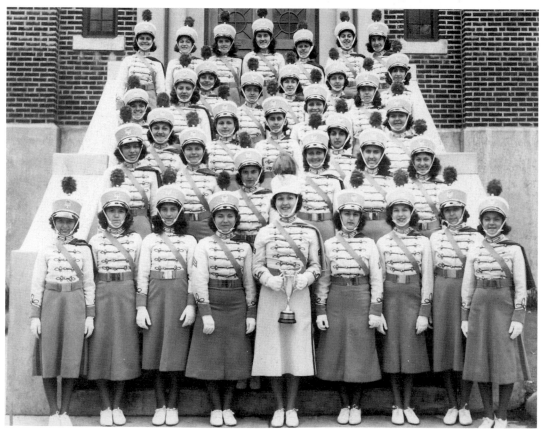

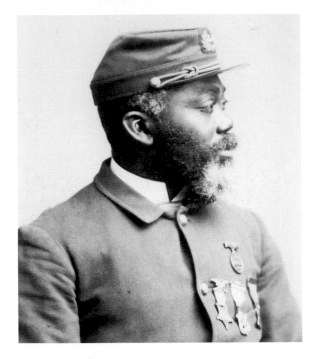

Sergeant William H. Carney was an African-American who served in the Civil War as a member of the 54th Massachusetts Volunteers, Company C, from New Bedford. He was the first African-American to be awarded the Congressional Medal of Honor for his outstanding valor.

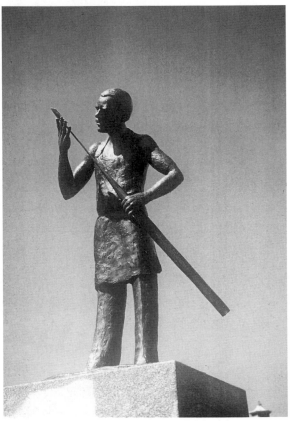

Lewis Temple (1800–1854) was the inventor of the iron toggle harpoon tip that "revolutionized the catching of whales." An African-American who was a blacksmith on the New Bedford waterfront, his invention led to New Bedford's place in the history of whaling.

six

Business and
Industry

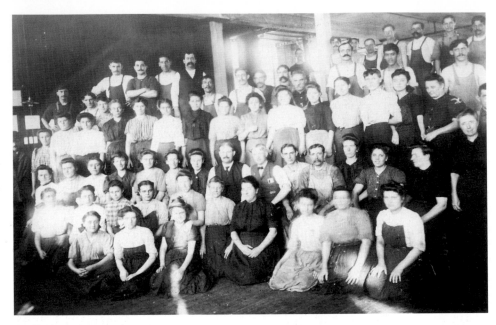

This group epitomizes mill workers in New Bedford at the turn of the century. By the late nineteenth century, the workers in the diverse mills came from all parts of the world. Many of them had specialized jobs, and a large number were women.

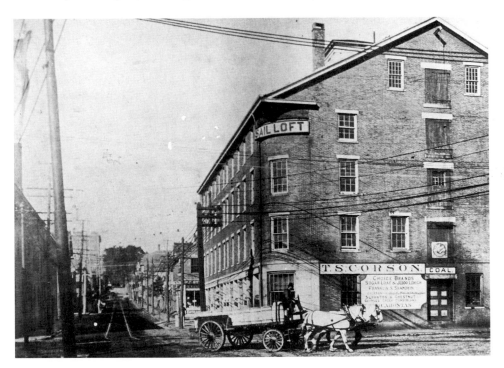

A sail loft was located in this brick block at the foot of Middle Street, at the corner of North Front Street. The canvas sails manufactured here were an integral part of the marine industry in New Bedford.

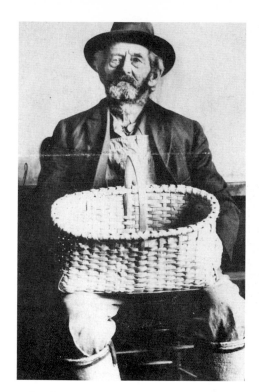
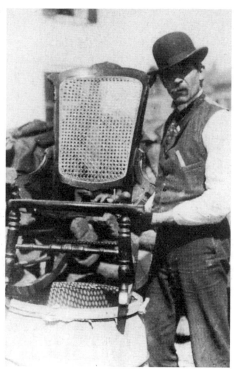

Left: John N. Hammond was a master basket weaver who, after retiring from a career as a carpenter, learned to make these utilitarian, but attractive, white oak baskets at his shop at 2941 Acushnet Avenue.

Right: "Whistling Joe," or Nelson I. Humes, was a caner in New Bedford who "probably got fifty cents for caning that chair." A well-known whistler, his "bird notes were the talk of the town."

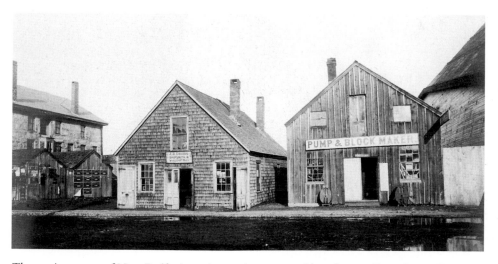

The marine aspect of New Bedford was in no place more evident than on Front Street. Here are the shop of J.D. Driggs, a shipsmith and whalecraft manufacturer, and the Coggeshall shop of pump and block makers.

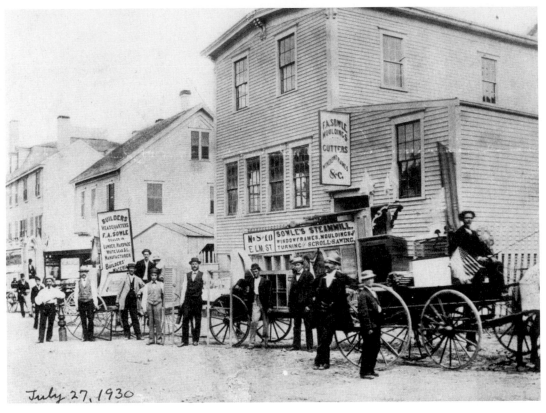

July 27, 1930

F.A. Soule's Planing Mill on Elm Street offered moldings, window frames, turnings, and scroll sawings, in addition to lumber for house building.

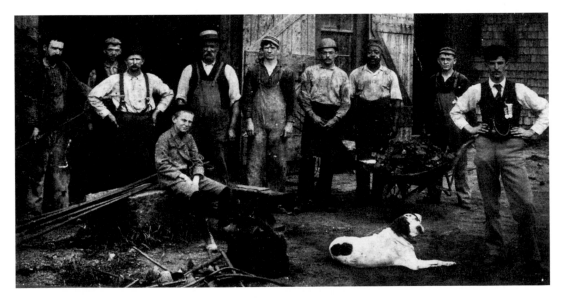

The night workers at the H.P. Davis Chemical Works at the corner of Chancery and Court Streets pose outside their factory, along with their watchdog.

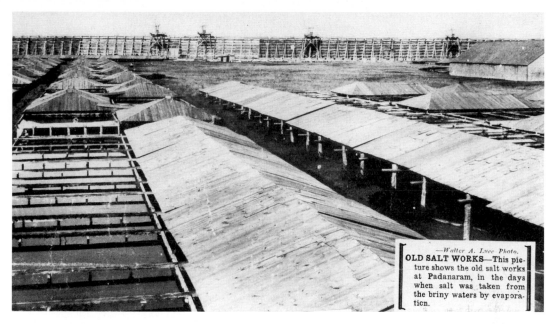

OLD SALT WORKS—This picture shows the old salt works at Padanaram, in the days when salt was taken from the briny waters by evaporation.

The Salt Works at Padanaram was an important business that separated salt from seawater.

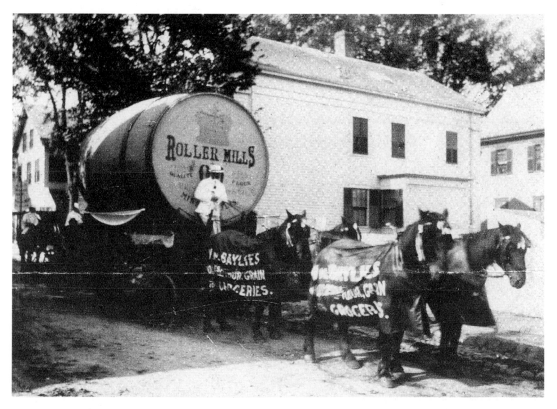

In a parade on Maxfield and State Streets during New Bedford's semi-centennial, robed horses pulled a giant "Roller Mills" barrel proclaiming the William Baylies Grain Company for all to see.

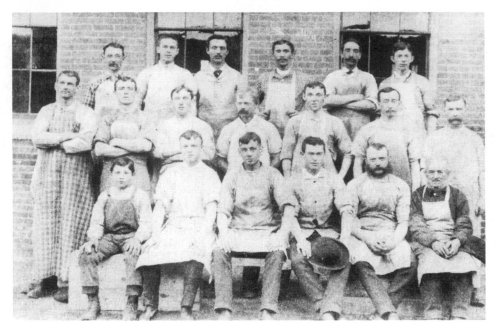

Employees of Pairpoint Glass Company in 1888 pose outside the glassworks. From left to right are: (front row) John Miller, James Almond, James Donaghy, Arthur Norris, George Washburn, and Captain Smith; (middle row) Harry Farnham, Walter Almond, Joseph Cronan, Walter Smith, Harry Smith, William Snell, and Jean Gill; (back row) Fred Haines, Courtland Shaw, George Munson, Charles Neagus, William Haworth, and Daniel Murray.

WM. J. ROTCH, Pres. A. SNOW, Jr., Treas.

MT. WASHINGTON GLASS CO.

F. S. SHIRLEY, AGENT.

New Bedford, Mass., U. S. A.

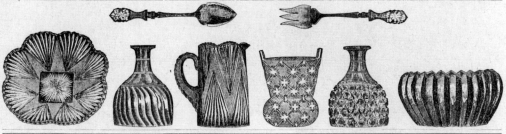

Rich Cut Glassware, Fine Decorated Shades and Lamps, The Celebrated Burmese Ware,
Crystal Chandeliers, Gas & Electric Shades, Globes, etc. Rose Amberina Ware,
Chemical Glassware, Electric Bulbs, Tubes, and Peach Blow Ware,
Philosophical Glassware. General Supplies for Electrical Uses. Pearl Satin Ware.

The Mount Washington Glass Company, founded in 1867 in South Boston, Massachusetts, relocated to New Bedford in 1880 after being purchased by William Libbey. It produced fine gold and silver plate and rich cut crystal. In 1894 it became the Pairpoint Corporation.

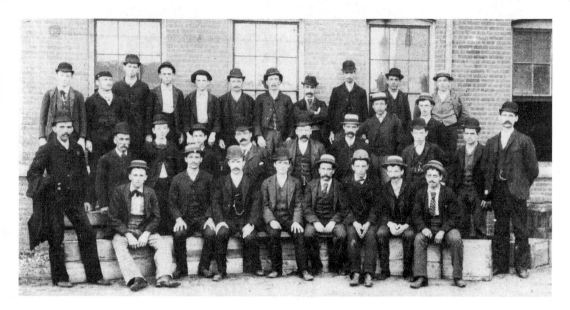

Employees of the Pairpoint Corpo ration pose in 1891 outside the factory. The Pairpont Glass
Company was well known for th

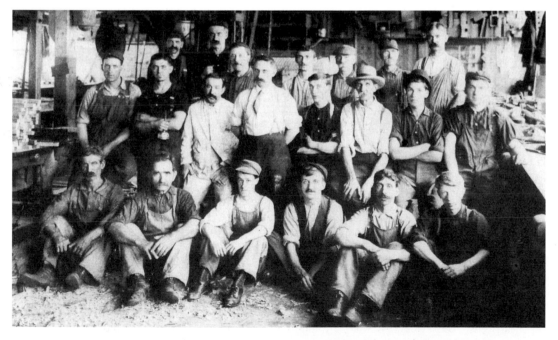

These employees of the Pairpoint Glass Company pose inside the factory *c.* 1917.

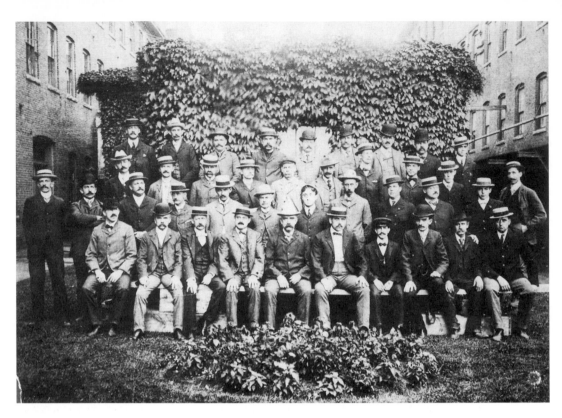

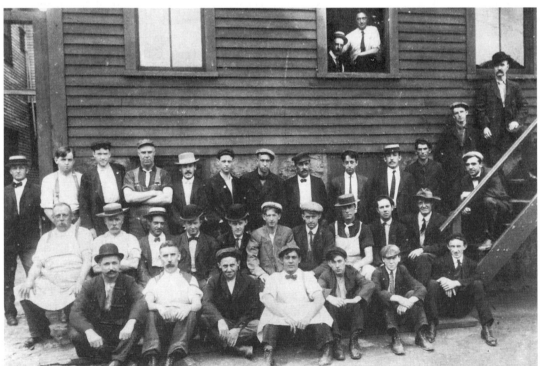

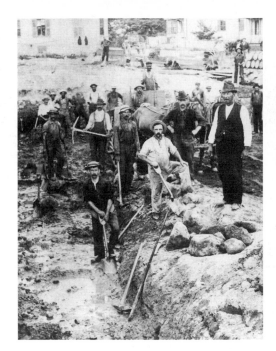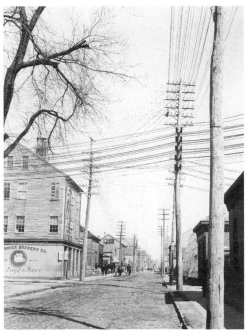

Above left: In 1899, ground is being broken for Dawson's Brewery on Holly Street. Peter Crapo, the construction boss, is on the right and Frank Holgate is in the trench in the foreground holding a shovel.

Above right: On Water Street, looking west, one could see a number of small businesses. This area had a large number of old houses that were converted to commercial property at the turn of the century.

Opposite above: Photographed in 1898 in front of Pairpoint's Engine House were, from left to right: (first row) Frank Taber, Joseph Davis, Timothy Canty, William Krebs, Henry Mosher, Jacob Lagendorfer, Charles Thomas, Joseph Timperley, Thomas King, and Arthur Silsbee; (second row) Thomas Tripp, Lyman Bauldry, Mr. Mitchell, Joseph Dias, Daniel Smith, Gilbert Stiles, George Sherman, Charles Farrington, Frederick Fish, Albert Steffin, Chester Best, and Elmer Thompson; (third row) William Clarke, Edward Perry, Louis Shurtleff, Albert Bingham, Wallace Barley, William De Costa, Arthur Drew, Frank Krebs, and Harry Boomer; (fourth row) George Turner, Curley Leary, Olympo Cayton, Samuel Aiken, Frederick Dunham, Emery Harvey, Albert Roscoe, James Aiken, and Victor Morrill.

Opposite below: The A.L. Blackmer Cut Glass Company was on North Second Street, and in 1907 their employees posed outside the factory. From left to right are: (first row) Frank Landers, Thomas March, John Borden, George Silva, Joseph Tobin, John McCarthy, and Allen Kennedy; (middle row) Thomas Wooley, John McManus, John Peters, Frederick Harrington, Eddie Pender, Jim Coffey, John McDonald, John O'Neil, William Godneer, Alexander Price, and John Marciel; (back row) John Mathews, John Bertham, Jim Brophy, Ted O'Neil, Harry Edgar, Frank Gregory, Harry Polock, David Dexter, Joseph Sylvia, John O'Connely, John Enos, William Tobin, and Andy Booth. In the window are Arthur Austin and A.L. Blackmer (proprietor).

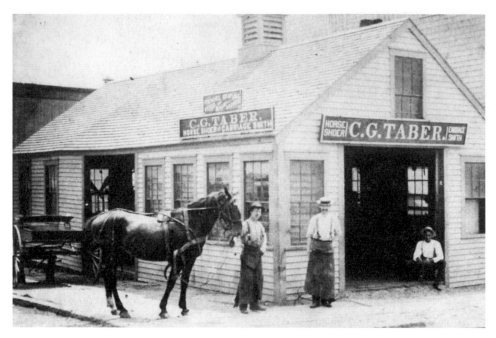

C.G. Taber, standing with a straw boater, was a ferrier and carriagesmith at this shop at the corner of Commercial and Water Streets. Also with Taber are Francis Tripp and Joe Henderson.

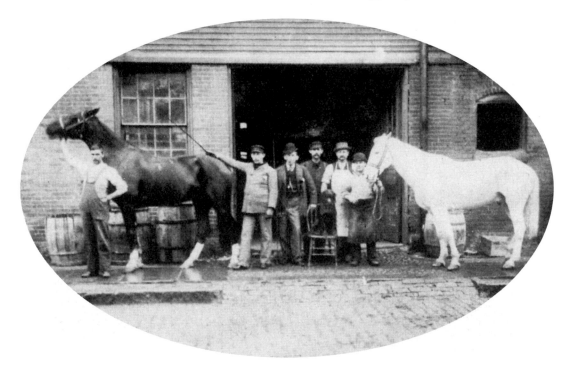

The Forbes Blacksmith Shop was on Acushnet Avenue near Elm Street. In front of the shop are, from left to right, Mr. Wilson, Peter Sinclair (caretaker), Mr. Tillinghast, Moses Cyr (carriagesmith), Mr. Allen (ferrier), and another Mr. Wilson.

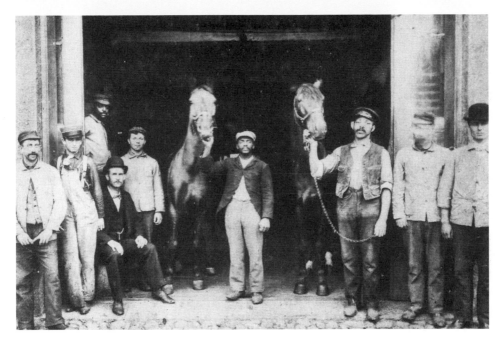

Posing in the door of the Perry Stables were "Major" and "General," the best horses in the Perry stable. The men in the photograph are, from left to right: (on the far left) William Powers, William Murphy, and William Davis; (standing in rear) Edward Lyons; (seated) Albert MacKinstray; (holding "Major") Solomon Broadway; (holding "General") Charles Saxon; (on the far right) Andrew McGee and Charles McCormick.

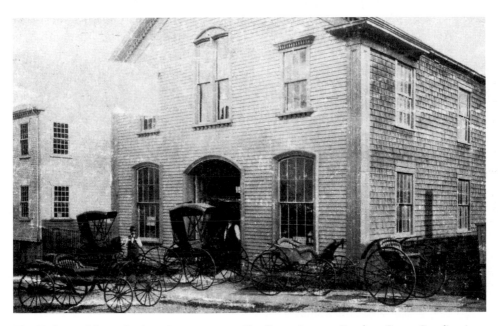

The Forbes and Sears Carriage Factory was on Elm Street, just past Purchase Street. Standing in the doorway is Henry H. Forbes, and on the left is James Forbes, his brother. The brothers had a large storehouse where many styles of carriages were available.

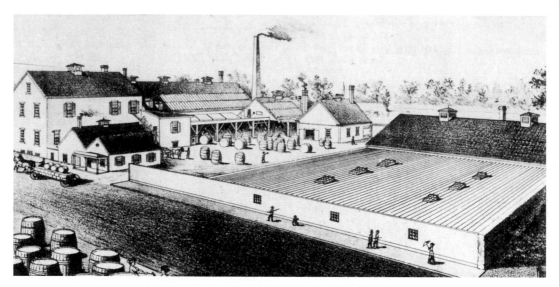

George Delano's Oil and Candle Factory was on South Street in New Bedford. In a print of 1881, barrels of whale oil stand in the foreground.

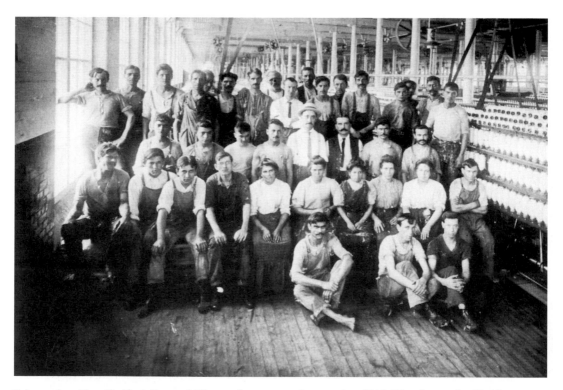

Spinners in a New Bedford Cotton Mill pose for a group photograph *c.* 1910. The thousands of bobbins that would be used in weaving cloth were at a standstill while the employees were photographed. By the turn of the century there were sixty-seven cotton mills in New Bedford, employing forty thousand workers.

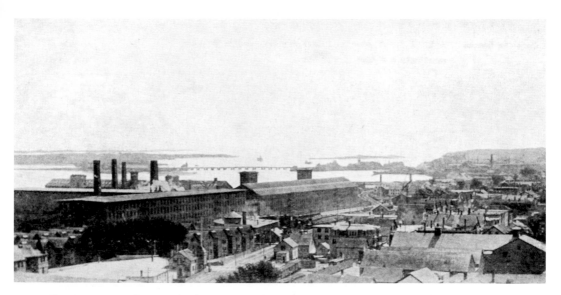

The Wamsutta Mills were the first textile mills in New Bedford. Founded in 1847, they stretched along the New Bedford waterfront and produced cotton shirting. In 1870, Wamsutta installed the largest stationary engine in the world at that time to provide power for the mills.

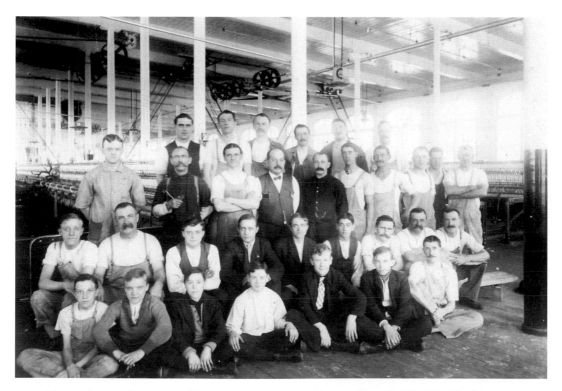

The workers in the cotton mills were of all ages. Young boys, often called "bobbin boys" and in some cases no more than ten years old, worked the bobbins as swiftly and deftly as did their mature co-workers.

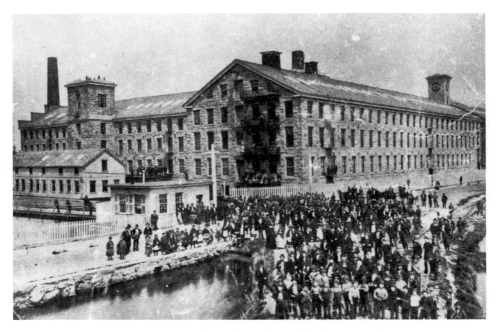

Employees of the Wamsutta Mills pose for a photograph *c.* 1870 in front of the granite mill.

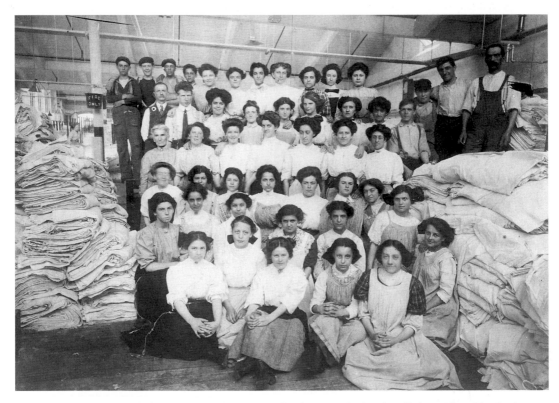

These women stopped their work of processing the shirting, which is bundled to either side, for a photograph *c.* 1905.

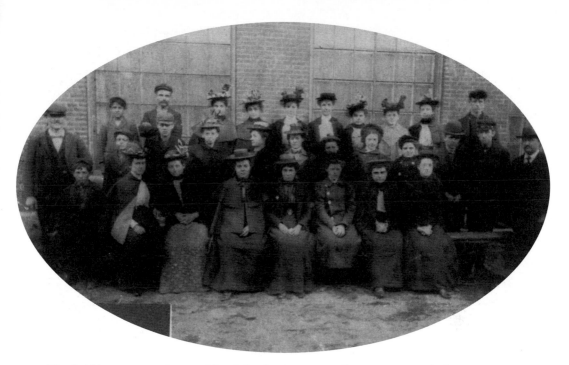

The finishing room employees of the Columbia Spinning Mill pose in 1898 with their overseer, Edwin Tanner, who stands on the right.

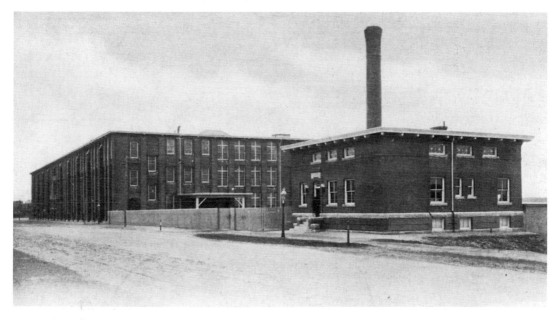

The Kilburn Mill, which was incorporated in 1904, produced high-grade combed yarns with almost seventy-five thousand frame spindles.

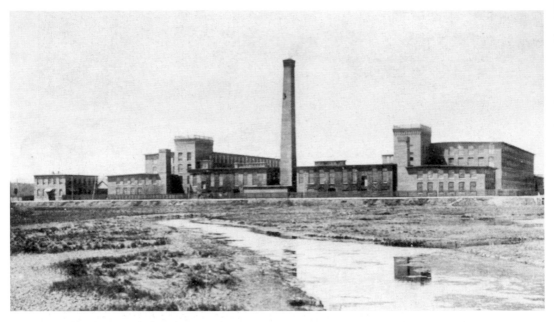

The Gosnold (formerly the Howland) Mill was one of the numerous mills in New Bedford that added to the total of two million spindles at the turn of the century. Incorporated in 1902, it was a leading cloth mill.

Two immigrants from Greece stand beside a power loom in a New Bedford textile factory in the 1930s. (Courtesy of Saint George's Greek Orthodox Curch.)

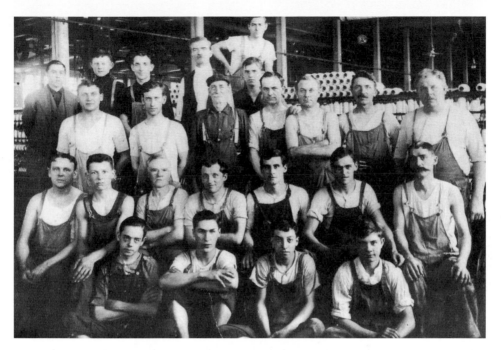

Members of the "mule room force" pose *c.* 1910 at the Bennett No. 2 Mill, which was incorporated in 1889. Their overseer was Fred Taylor, who stands on the left.

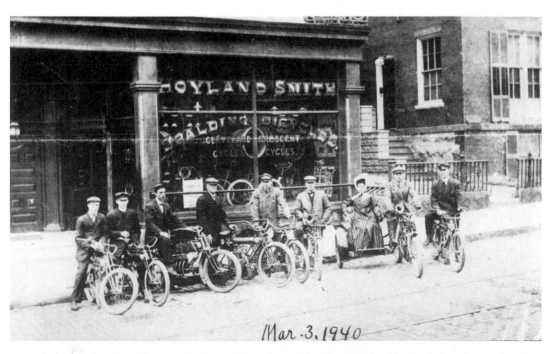

A group of motorcyclists pose in front of Post One of the American Legion, located at the corner of Union and Sixth Streets. Hoyland Smith owned the cycle shop, which also served as the headquarters of the Darmouth Cycle Club for many years.

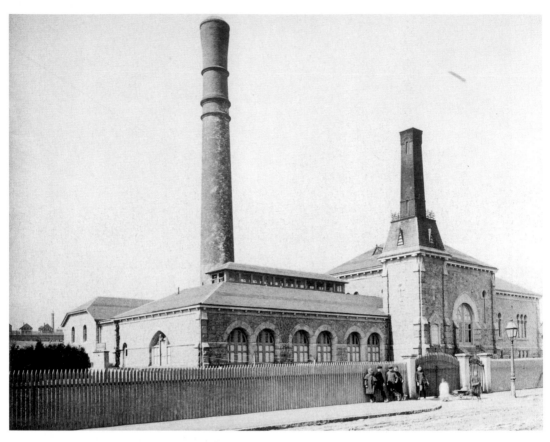

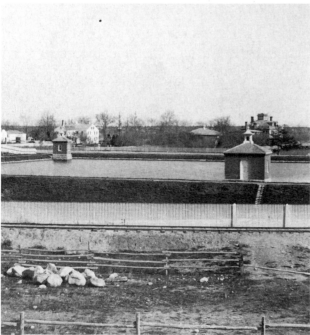

Above: The pumping station of the New Bedford Water Works was an impressive Romanesque Revival structure that pumped and refined water for the city from 1869 to 1899. A group of children stands by the entrance at the turn of the century.

Left: The reservoir, where the water was pumped, was surrounded by a high fence to keep all unwanted people and animals from the area. After 1899, the water was drawn from Great and Little Quittacas Ponds.

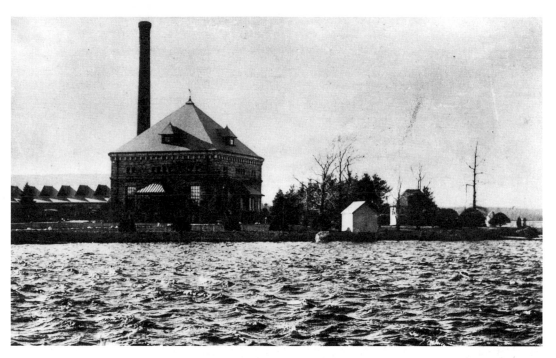

Seen from the reservoir, the pumping station was a marvel for its day and had an enormous influence in bringing manufacturing corporations to New Bedford.

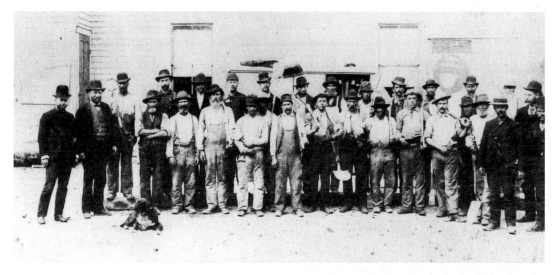

Members of the New Bedford Water Department in 1886 pose for a photograph. From left to right are: (front row) Robert Coggeshall, Frank Ashley, Fred Lyng, Domingos Sylvia, George Smith, Frank De Mello, Napoleon Hennier, John Hennier, John De Mello, Jack Murphy, Patrick McCullough, John De Mello Jr., and Joseph Rose; (back row) Maurice Downey, Patrick Reardon, Michael O'Brien, Thomas Rose, Ventura Bettencourt, Joseph Antone, John Carroll, and Louis Richardson. The dog belonged to Frank Ashley.

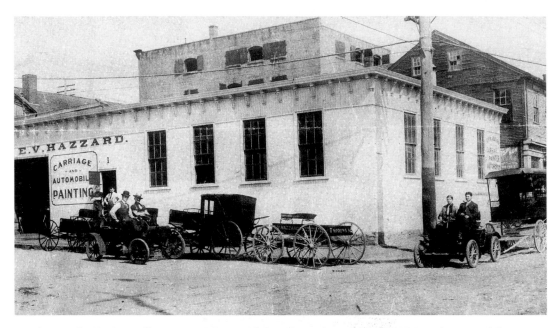

Employees of E.V. Hazzard's carriage and automobile painting shop posed *c.* 1905 in early automobiles.

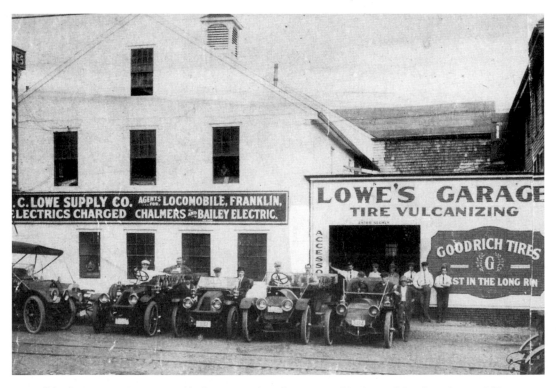

One of the first garages in New Bedford was Lowe's at the corner of Spring and Purchase Streets. This 1911 photograph shows Isaac Ashley Jr., Everett Corson, Isaac Ashley, Earl Machney, Emile Grenier, Herbert Atkinson, Roy Wordell, and Fred Murphy— all posed and ready for a spin about town!

seven

Whaling

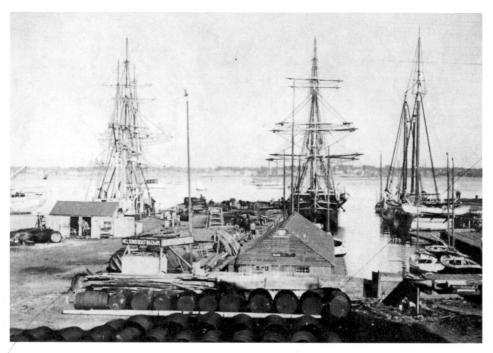

The New Bedford wharf in the 1870s was a busy place with three ships at dock; on the left is the bark *Platina*, in the center is the bark *Morning Star*, and on the right is the schooner *Golden City*. Nelson's Boat Bazaar, where one could let a sailboat or a rowboat, is in the foreground.

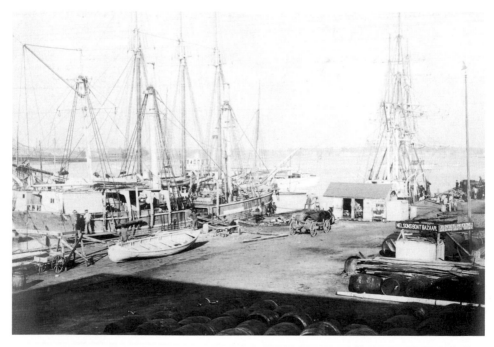

The arrival of the bark *Kathleen* was an exciting day. Built in 1844, the bark was an early whaler that would serve the industry for almost six decades. It was sunk by a whale in 1902.

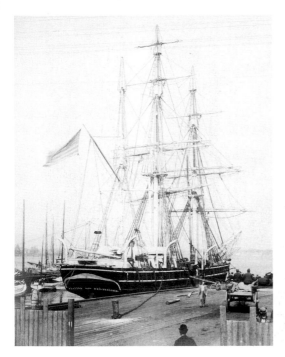 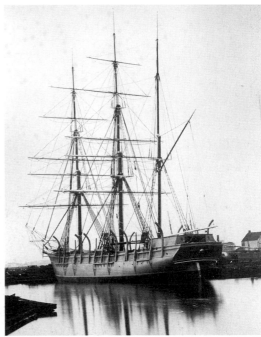

Above left: The ship *Platina* was built in 1847 and was photographed at the turn of the century ready for sea. The ship was abandoned in 1914.

Above right: The bark *Concordia* was photographed on Howland's Wharf in New Bedford prior to its departure on December 7, 1867. Commanded by Captain Robert Jones, the bark was wrecked on its first voyage in 1871 in the Antarctic.

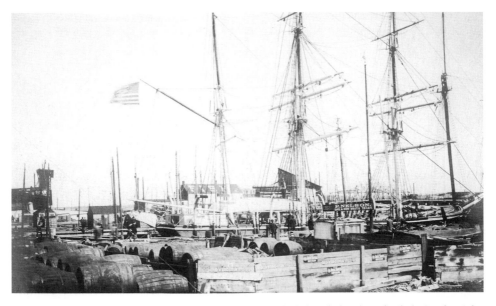

The bark *Sunbeam* is at dock with some of the barrels of whale oil already unloaded. On the right was Nelson's, where one could let a sail or rowboat.

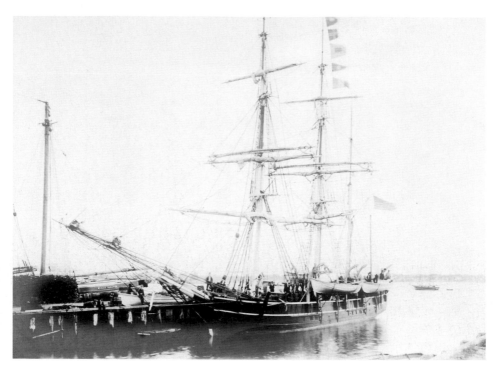

The bark *President* was ready for sea about 1869. Her sails are furled and the flying pennants are flapping in the wind.

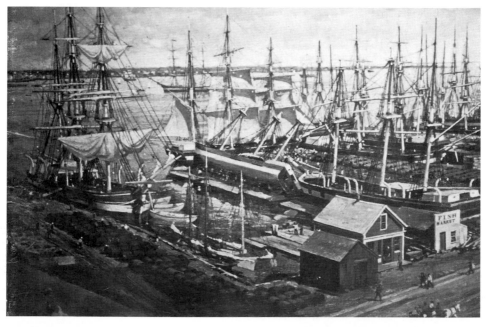

New Bedford wharves in the mid-nineteenth century teemed with activity. Not only were whaling ships a major source of activity, but so too were the fisheries. A small fish market is in the foreground of this wharf where "ocean fresh" fish was available daily.

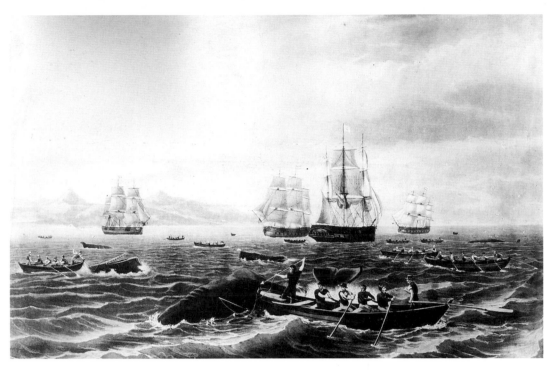

These whalemen are capturing a sperm whale that has been caught by harpoons and has run its course. The boats were manned by six whalers apiece; the ships in the background await the catch.

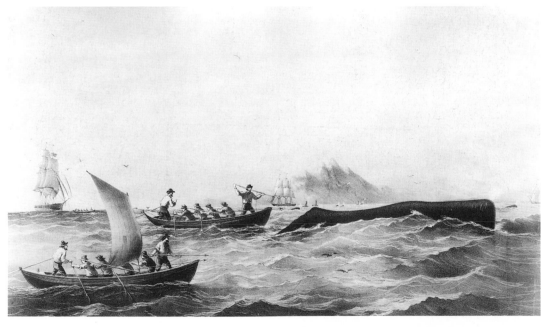

Once a whale was sighted, the whalemen would lower the boats and begin the chase. A whaleman, with harpoon poised, would try to harpoon the whale and a "New Bedford sleigh ride" would ensue—the whale would drag the boat by the attached harpoon and line through the water.

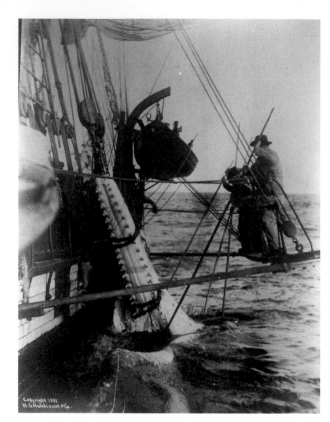

Left: Two whalemen cut in a sperm whale while standing on a stage that projects from the ship. Here they are severing the whale's lower jaw with cutting spades.

Below: Whalemen are shown here taking in a right whale's head. This furnishes baleen, or whalebone, that was used for a variety of things, including corset stays.

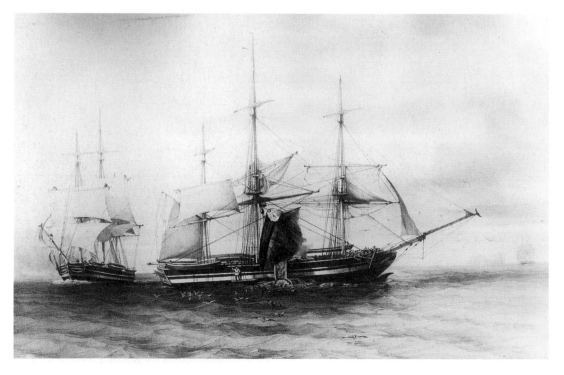

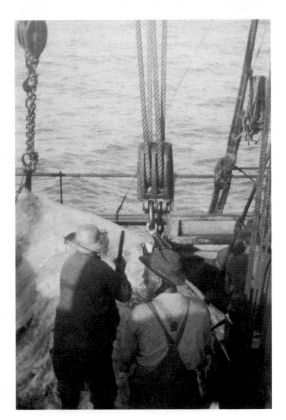

Whalemen would begin cutting the whale parts as soon as they were hoisted onto deck.

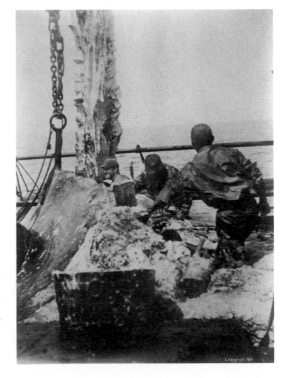

These whalemen are bailing out the case, which is the upper portion of the whale's head. The head, when rendered, would produce almost 20 gallons of pure spermaceti, a waxy solid used in ointments and candles.

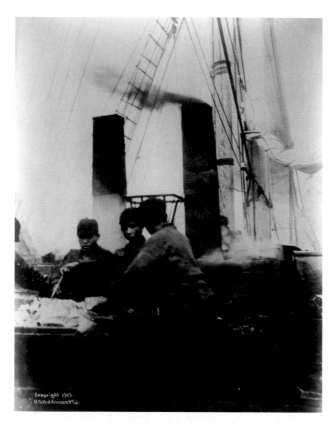

Copyright 1903
H.S.Hutchinson&Co.

Left: Whalemen are shown here mincing whale blubber that was soon to be rendered into pure whale oil.

Below: Men stand "downwind" as best they can to avoid the odor of whale blubber being rendered. Huge pots were set up on deck with brick ovens to contain the fire; men would add pieces of whale blubber to the pot to render it into oil.

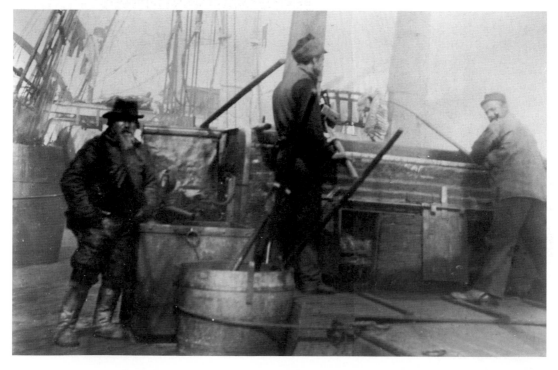

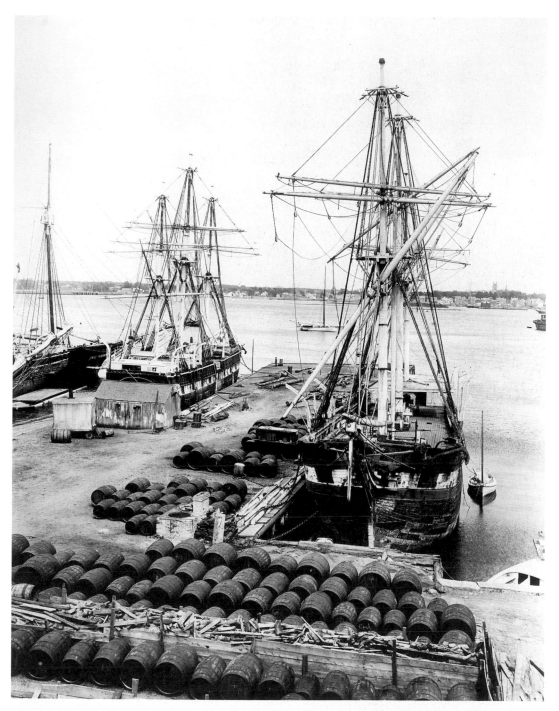

The ship *Warrior* (right) lies at dock in New Bedford after a whaling voyage. Some of the barrels of whale oil have already been unloaded and are stored on the wharf. This scene was a common one a century ago, when millions of gallons of whale oil passed through New Bedford.

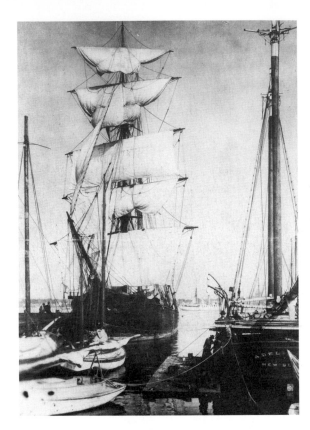

Left: The bark *Lonora* (left) is drying her sails after a voyage about 1885.

Below: After a long voyage, the bark *Sunbeam* is at dock in New Bedford drying her sails. Unless the sails were unfurled to dry, the canvas would rot.

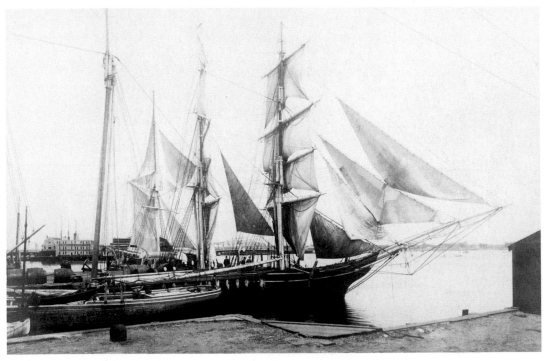

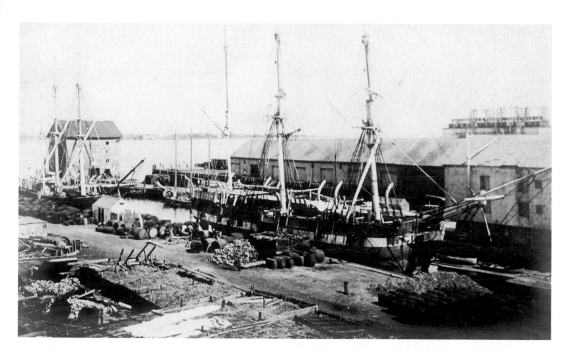

Taber's Wharf was a busy place when ships arrived. The bark *Falcon* lies at dock near barrels of whale oil.

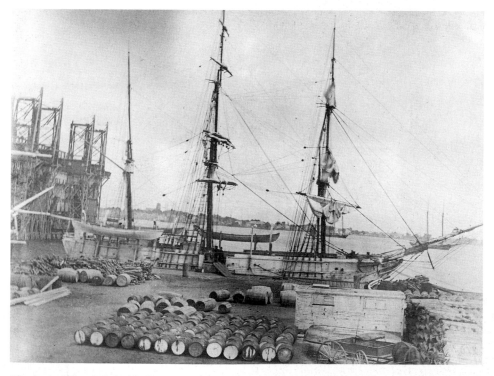

The bark *Calapa* is being unloaded at New Bedford about 1875. The whale oil was rendered and then barreled before the ship even headed for home.

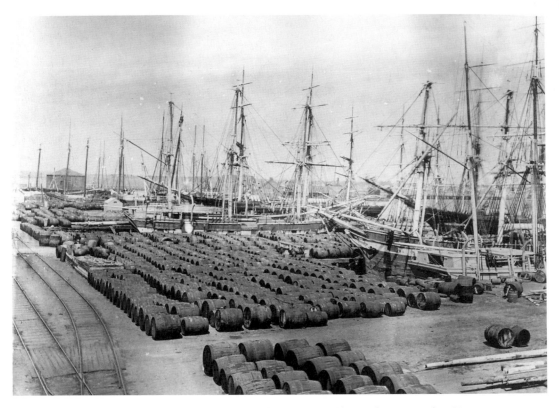

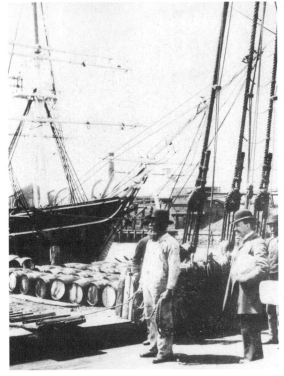

Above: When a ship returned to New Bedford after whaling, hundreds of barrels of whale oil would be unloaded and stored on the pier until brought to a warehouse.

Left: These men were coopers who created a wood barrel out of staves and metal bands. Coopering is now almost a lost art, but a century ago it was a well-known industry in New Bedford.

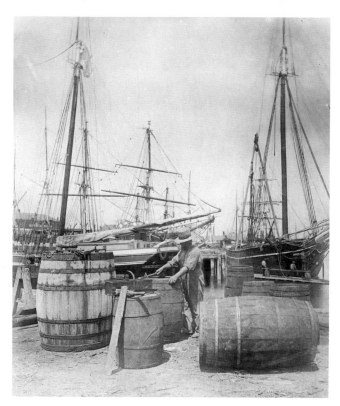

A worker coopers oil in hogsheads, the 40-gallon barrels that held rendered whale oil.

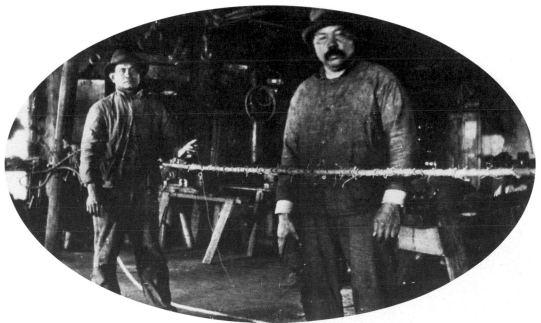

Raymond Girado (left) and Joaquim Pandelina served rigging for the ships being outfitted in New Bedford. Employed at Howland and Sampson's Sail Loft, these two natives of Guam produced work that "has been blown over the Seven Seas."

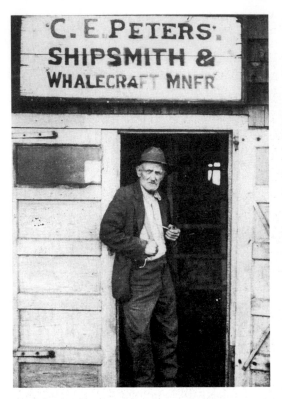

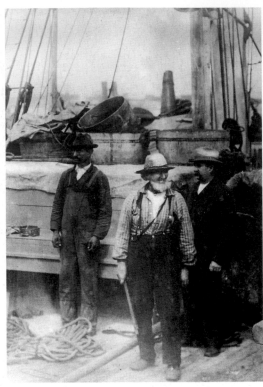

Above left: Edmund Taylor, a veteran master of the whalecraft trade, stands in the doorway of the shack of C.E. Peters' Shipsmith & Whalecraft Manufacturing Shop on Merrill's Wharf.

Above right: Frank Lewis stands on deck of a whaling ship with two workers ready to collect whalebone being brought to port. Notice the metal pots that were used in the rendering of the whale oil.

Left: Frank Lewis stands before a large number of whalebones that were brought to port after the ambergris was rendered. Lewis was a "bone scraper" for the J. & W.R. Wing Company.

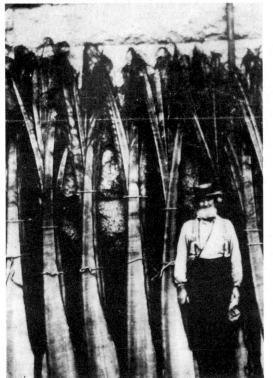

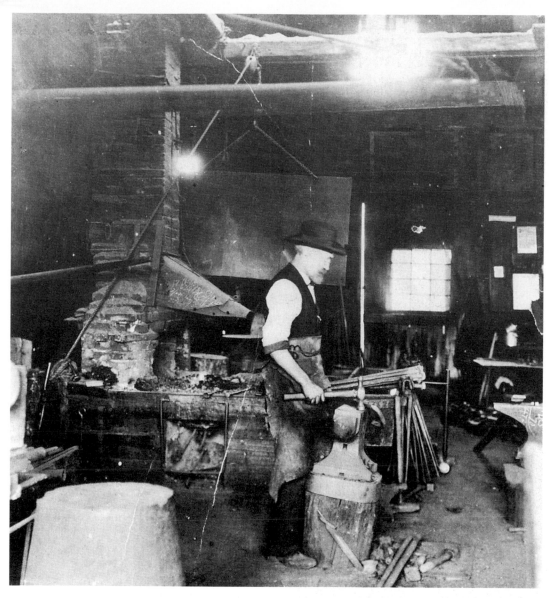

A blacksmith was an important worker on the wharfs. In a shop on Front Street, a blacksmith, complete with derby, stokes the fire and readies metal to be forged.

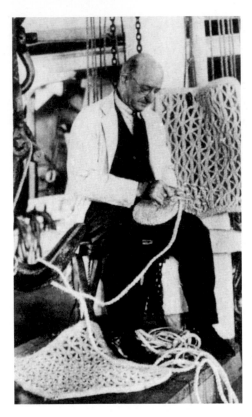

Left: Captain David Pierce, of the *Lagoda,* made use of his spare time while at dock to make ship mats from rope.

Below: The bark *Kathleen* was docked in New Bedford at the foot of the wharf in front of the New Bedford Cordage Company. The rigging was comprised of rope that was produced locally and from the Plymouth Cordage Company. Miles of rigging were necessary to set sails for an ocean voyage.

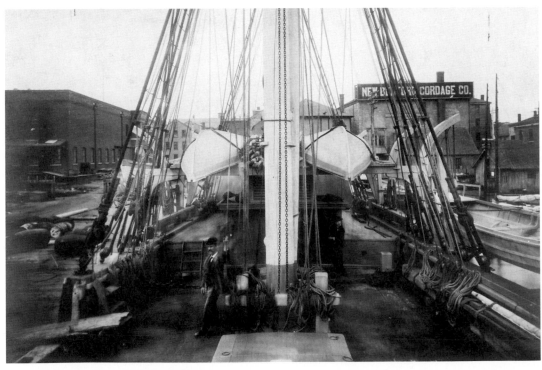

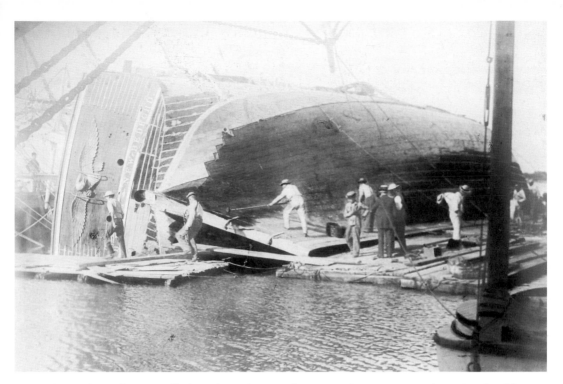

The *Sunbeam* of New Bedford was hove down in the 1890s to begin repairs to the underside of the ship's hull.

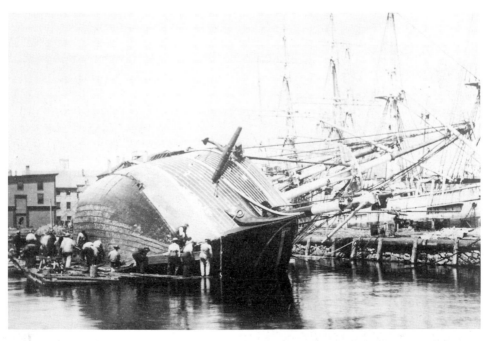

A ship has been hove down to scrape the bottom of the ship and ready it for coppering and sheating. This important step was to ensure that the ships had a long life of service.

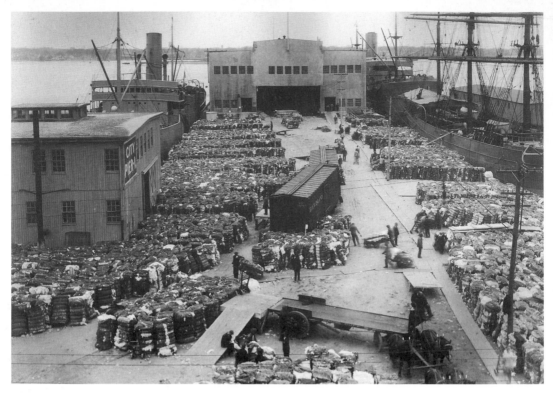

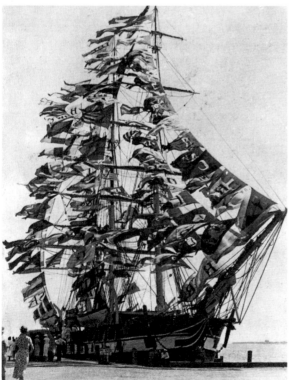

Above: The State Pier in New Bedford in 1918 was inundated with cotton goods that were being loaded on ships and freight cards for distribution throughout the country. New Bedford's cotton mills were among the most important in the country at the turn of the century.

Left: The *Charles W. Morgan* was in "full dress" in the 1920s. Today the ship is docked at Mystic Seaport in Mystic, Connecticut.

Eight

Residences

County Street is still one of the most elegant streets in all of New Bedford. Looking from the corner of Walnut Street, County Street is the site of numerous mansions of the wealthy residents of the city.

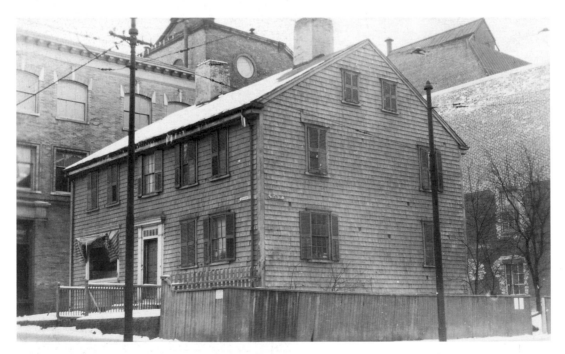

Caleb Greene built his house on a lot of land deeded to him by his father-in-law, Joseph Russell, on Union Street. A small five-bay house, it was converted to a shop by the turn of the century.

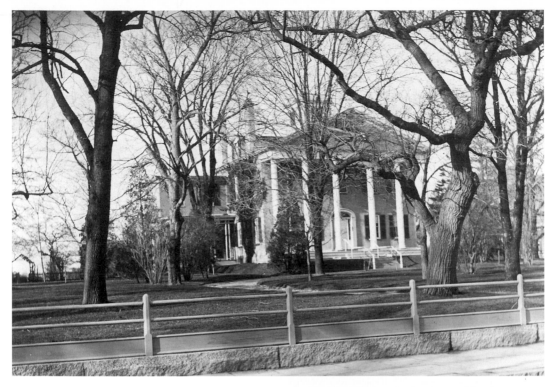

Above: The Morgan House was an impressive Greek Revival mansion that was prominently sited at the head of William Street. The family spared no expense embellishing the grounds with trees and gardens.

Left: Charles W. Morgan was a wealthy resident of New Bedford and one of the famous whaling ships, the bark *Charles W. Morgan*, was named in his honor. He married a daughter of Samuel Rodman, who built a mansion for them upon their marriage.

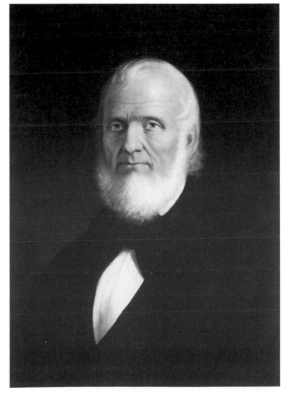

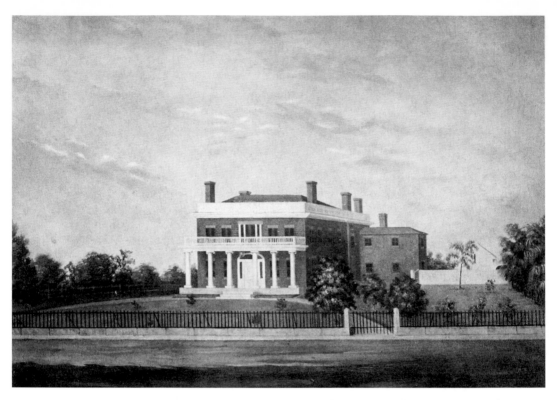

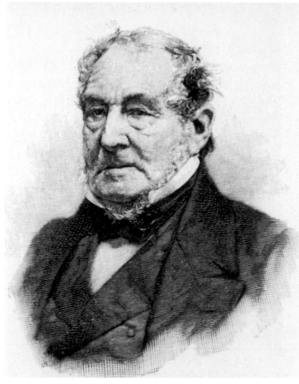

Above: The Arnold Mansion was built in 1821 on County Street at the head of Spring Street. James Arnold was an avid horticulturist and "Arnold's Garden" was open to the public. Maypole dances held here marked the rite of spring and visitors came from near and far to see the gardens. Today this is the Wamsutta Club.

Left: James Arnold was the man for whom the Arnold Arborteum was named. The famous arboretum in Boston was formerly the estate of Benjamin Bussey, who left it to Harvard to promote agriculture and horticulture. It was Arnold's bequest to Harvard that began one of the most famous arboretums in the world.

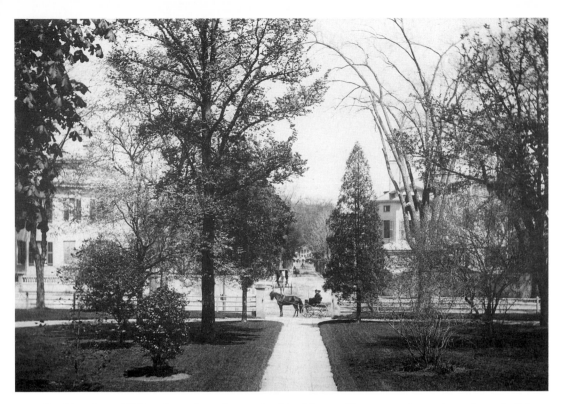

Looking down William Street from the porch of the Morgan House, a carriage waits at the end of the walk.

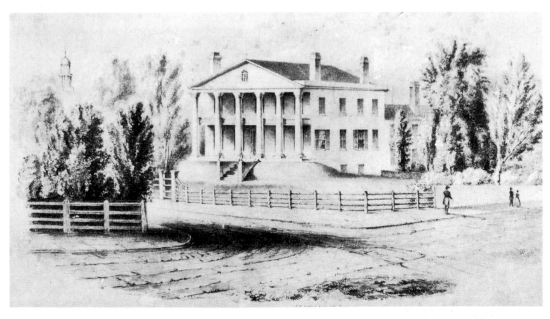

Joseph Rotch built his mansion on William Street, between County and Eighth Streets, on land given to him by his father, William Rotch Jr. The property was later subdivided and the mansion demolished.

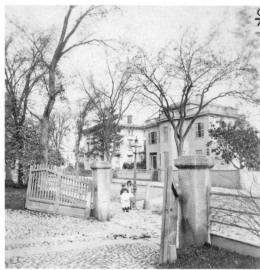

Left: H.H. Forbes lived in this impressive three-story mansion on Pleasant Street. Originally built by Charles Russell, it was later to become Saint Joseph's Hospital.

Right: The Ingalls and Doane Houses were on County Street. Two young girls stand by a street light *c.* 1860.

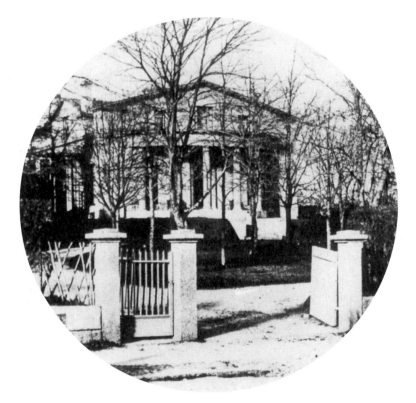

"Greystones" was the home of Henry M. Dexter, editor of *The Congregationalist*. Built on County Street, near Merrimac Street, it was set back from the street with granite gateposts that gave it its name.

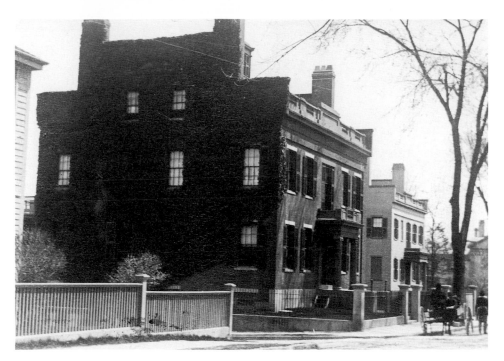

The Coffin-Allen House was built in 1833 at the corner of Walnut and Sixth Streets. A substantial brick mansion, it was built for David Coffin, who came from Nantucket.

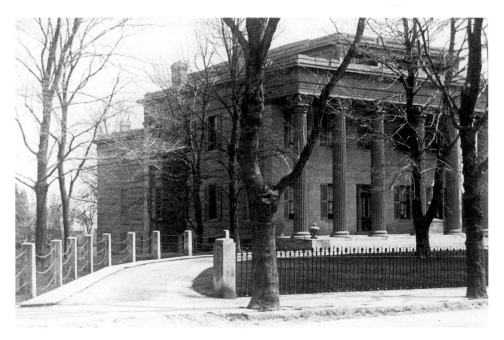

The Rodman-Howland House was built in 1833 at 388 County Street and is a massive colonnaded mansion set back from the street by a circular drive that was bounded by granite posts connected by chain. One of the more spectacular houses designed by Russell Warren, it was the home of Abraham Howland, first mayor of New Bedford (1847–1852).

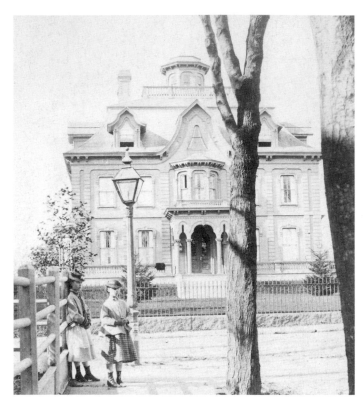

Dr. Edward P. Abbe's house was a fanciful Italianate house at 405 County Street. Two girls stand in front of the house that had "Flemish" gables and dormers and an octagonal cupola from which superb views could be appreciated.

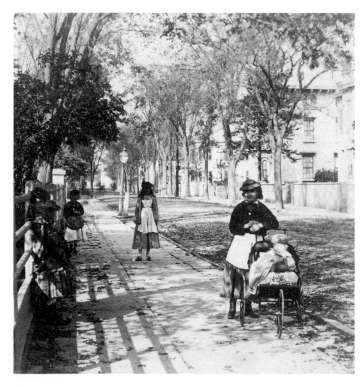

Looking down County Street, from Court Street, about 1860, a mother with a perambulator stops for the photographer. With trees shading County Street, it was a pleasant place for a summer afternoon stroll.

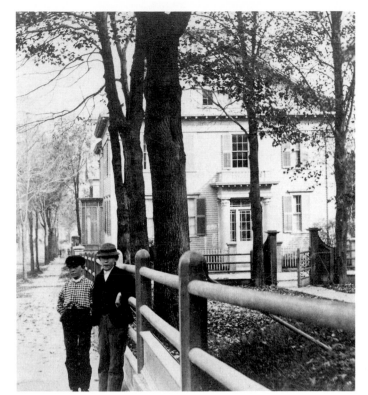

Right: Two boys stand by the fence at the Knowles House, which was at the corner of William and Eighth Streets.

Below: Hawthorne Street, *c.* 1885, was a tree-lined street with houses set back on spacious lots.

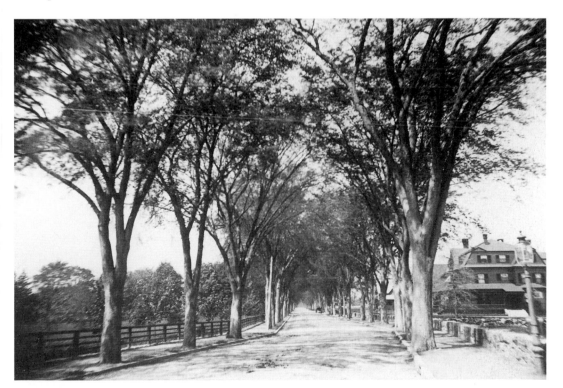

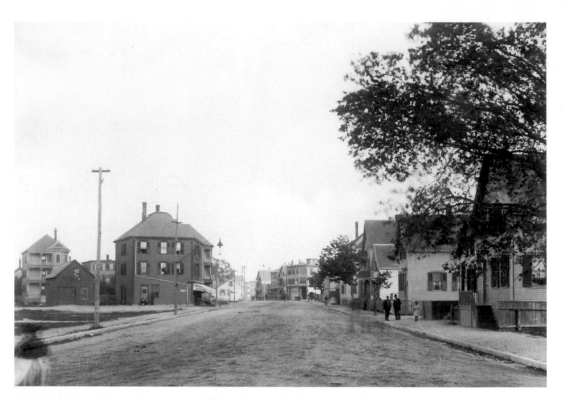

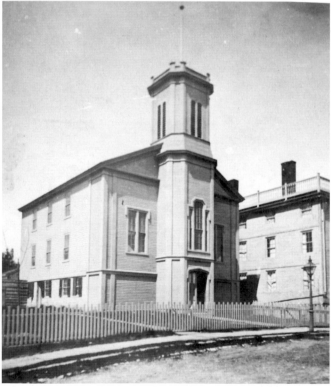

Above: Cove Street, shown in the eastward view from County Street, was developed in the late nineteenth century with small houses and "three deckers." Three deckers were built with individual apartments for three families, with front and back porches and windows on all sides. They were often spacious and modern compared to the tenements, the only other alternative.

Left: The Seamen's Bethel in New Bedford is a place to contemplate the precarious life led by whalers in nineteenth-century New Bedford. As a bethel, it still offers a place to mediate and remember the men who went down to the sea.

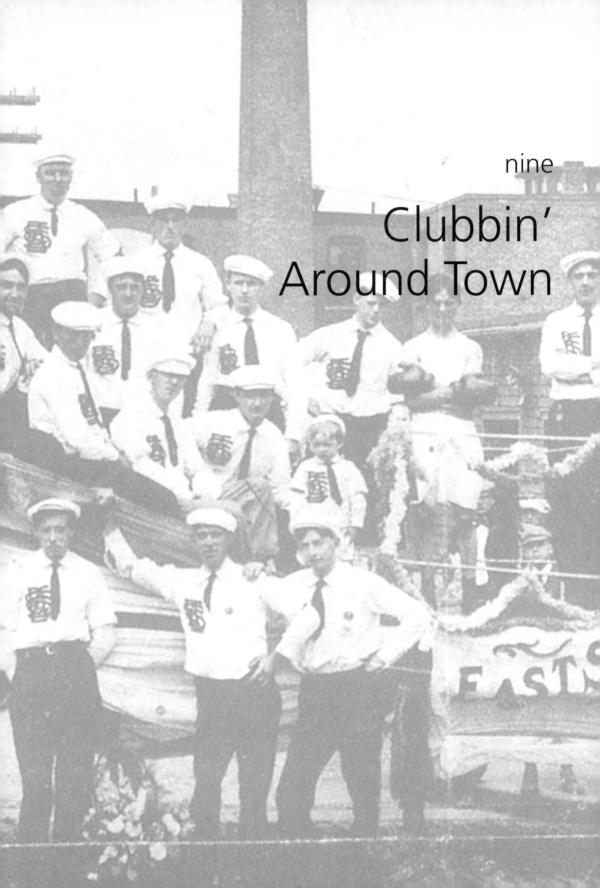

nine

Clubbin'
Around Town

Members of Post One of the Grand Army of the Republic were veterans of the Civil War. Among the brave veterans in the photograph are Sergeant William H. Carney (the hero of Fort Wagner), Commander T.W. Cook, and John J. Holmes.

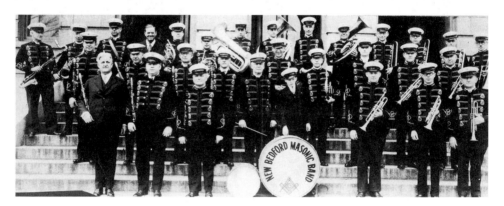

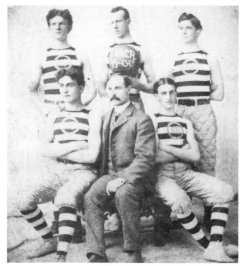

Above: The New Bedford Masonic Band proudly poses with its instruments *c.* 1930.

Left: Members of the New Bedford YMCA basketball team of 1899 and 1900 pose for a photograph. From left to right are: (front row) William Gatenby, Louis Surdam, and Fred W. Steele; (back row) Fred Jones, Rossa Moriarity, and Frank Jones.

Opposite below: The New Bedford Young Men's Christian Association (YMCA) was a brick and granite Romanesque Revival building with an impressive conical-roofed tower.

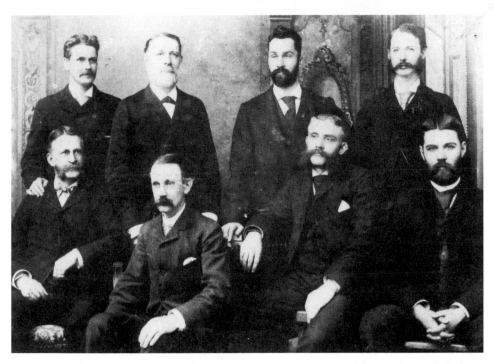

Directors of the New Bedford YMCA posed for a photograph in 1890. From left to right are: (seated) Ray Greene Huling, Edward T. Tucker, Charles S. Kelley, and chairman Nat W. Gifford; (back row) W.E. Lougee, Edwin Emery, Dr. W.H. Kennicutt, and R.F. Raymond.

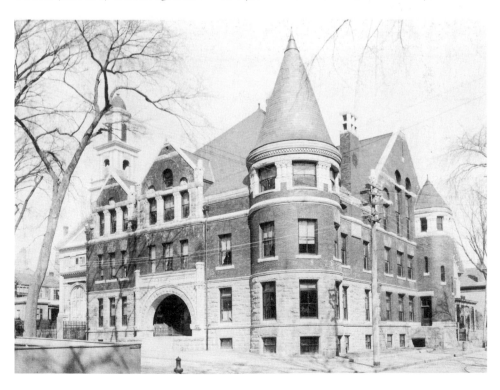

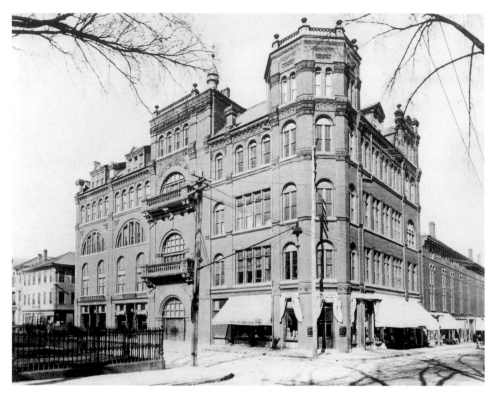

The Odd Fellow's Hall was a panel brick building where members of the Independent Order of Odd Fellows (IOOF) met for meetings. Odd Fellows were benevolent brothers, similar to Masons, who as members did good works, and benefitted from camaraderie.

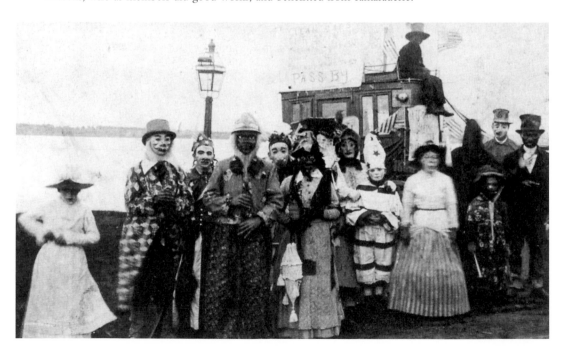

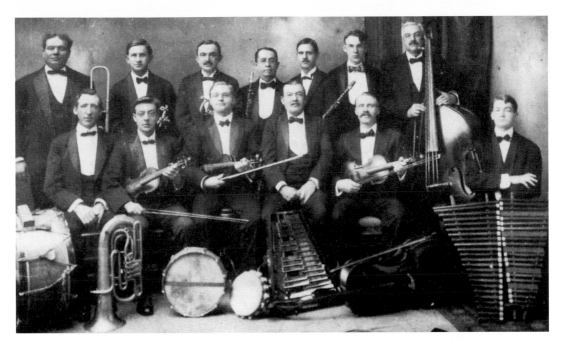

Above: Gray's Orchestra performed at many dances held at club functions and private homes. The musicians shown here in 1903 are, from left to right: (seated) John Curry, Robert Scott, Frank Whittaker, Henry Gray, Harry Bamforth, and Leonard Gray; (standing) Joseph Goudreau, L. Robert Yeager, Edward Gray, Clarence Holmes, Charles Sawyer, Arthur Geldard, and James Rockefeller.

Below: The "Wamsutta Minstrels" presented a minstrel show at the Wamsutta Club on April 5 and 6, 1910. The Wamsutta Club is located in the former mansion of James Arnold on County Street.

Opposite below: "Horribles" were people who dressed in odd costumes and participated in a "Horribles Parade," usually on the Fourth of July. Here members parade in 1888 with the old New Bedford-Fairhaven stagecoach following this oddly attired group!

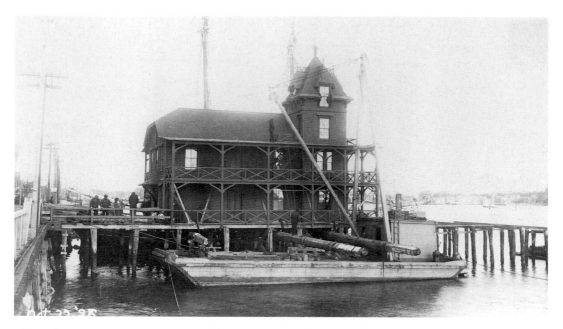

The Yacht Club was a Stick-style clubhouse built on pilings off the Fairhaven Bridge. A floating barge is in front of the clubhouse that was moved when the new Fairhaven Bridge was built.

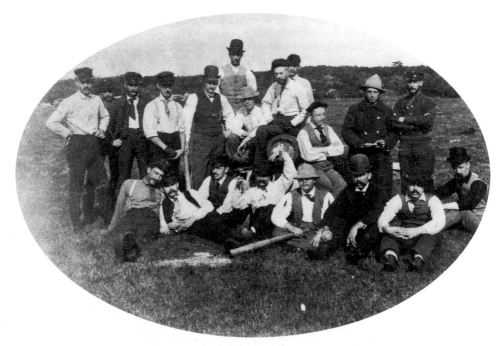

Members of the New Bedford Yacht Club enjoy a picnic c. 1890. They are, from left to right: Lyman Montague, Charles Allen, Albert Holmes, Arthur Forbes, George Shockley, Harry Taber, E.W. Bourne, Dr. Edward Weeks, Thomas Donaghy, Edgar Lewis, John Barrows, Roland Leonard, Arthur Tucker, Charles Baylies, Carl Wood, Andrew Pierce, E.P. Haskell, Mr. Murray, and Mr. Gifford.

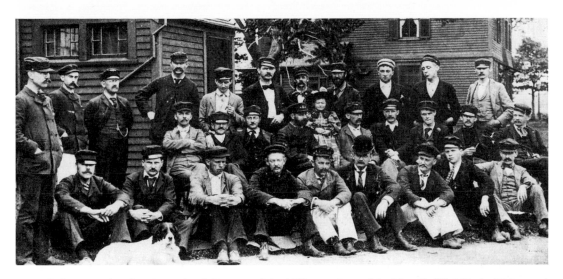

Before a weekend cruise to South Dartmouth in 1889, members of the New Bedford Yacht Club posed for a group portrait. From left to right are: (front row) John Baylies, Frank Clarke, John Rhodes, Edgar Lewis, Dr. Whitney, George Tripp, James Stanton, Fred Fish and H.K. Snow; (middle row) H.H. Hathaway, J.K. Nye, Dr. C.W. White, E.B. Hammond, Maurice Dahill, Carl Wood, Henry Wood, F.C. Haskell, and Fred Stanley; (standing) Charles Baylies, A.S. James, Horace Wood, Nat Hathaway, Benjamin Anthony, Andrew Snow, Charles Parker, H.F. Hammond, R.A. Terry, Frank Cummings, and Dr. Waite.

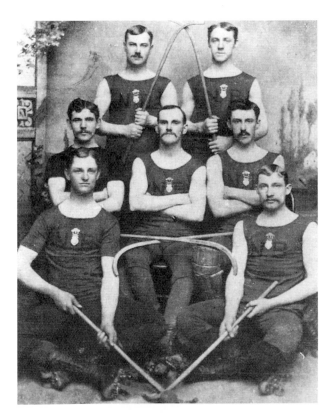

Polo was played at the Bijou Rink in the 1880s by this group of friends. From left to right are Samuel France, Fred Cook, James Hathaway, Edward Cook, John Butler, James Canavan, and John Bannister.

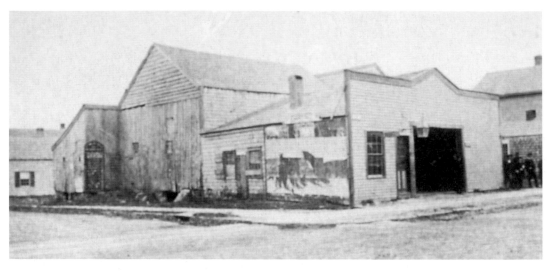

Above: The Bijou Rink was a popular place for all sorts of athletic events, and is shown here in 1884.

Below: The interior of the rink had Japanese lanterns strung from the rafters in anticipation of an evening event.

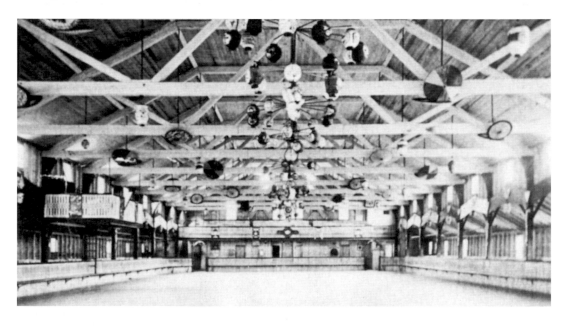

Opposite below: On an outing to Cuttyhunk Island in 1913, the members of the New Bedford Bar Association posed outside the towboat office on Merrill's Wharf. From left to right are: (first row) James Doran, Charles Mitchell, Judge Frank Milliken, Judge Hugo Dubuque, Lemuel Wilcox, Judge James Morton, William Parker, Joseph Kennedy, Judge Mayhew Hitch, Clifford Sherman, and Daniel Devoll; (middle row) Justus Briggs, T.F. O'Brien, Thomas Cunniff, Frank Sparrow, Lemuel Dexter, George Potter, I.C. Dade, William Smith, and Henry Worth; (back row) Otis Cook, Edwin Douglass, Joseph Gauthier, Frederick Stetson, Edward Clarke, Charles Serpa, Walter Mitchell, Norton Shaw, Morris Brownell, Solomon Rosenburg, Allen Milliken, and George Gardiner.

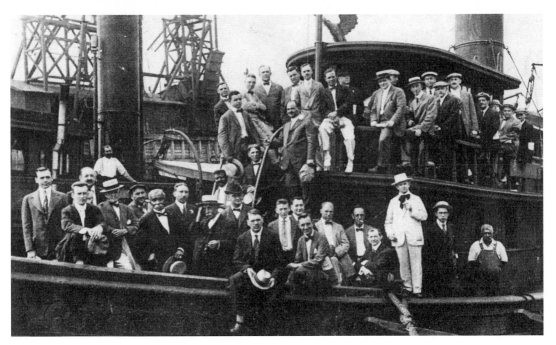

Above: Members of the New Bedford Bar Association held an outing to Falmouth Heights in 1916. From left to right are: (first row) Charles Archambault, George Gardiner, Daniel Devoll, James Doran, Walter Mitchell, William Smith, Henry Woodward, Clifford Sherman, D.E. Terra, Asa Auger, John Leary, Solomon Rosenberg, Joseph Francis, G.C. Hathaway, Morris Brownell, Gerret Geils, and Judge Joseph Walsh; (back row) Isaiah Dade, George Potter, James McCrohan, George Munsey, Samuel Bentley, Joseph Kennedy, Patrick Doyle, Frederick Taber, N. Nadeau, Charles Sawyer, Lemuel Dexter, Charles Connor, Edward Holmes, Frank Rogers, M.C. Fisher, Judge Mayhew Hitch, Justus A. Briggs, E.B. Jourdain, George Cram, Joseph Gauthier, and P.B. Gifford.

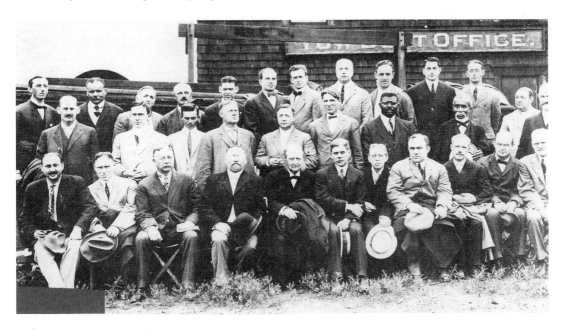

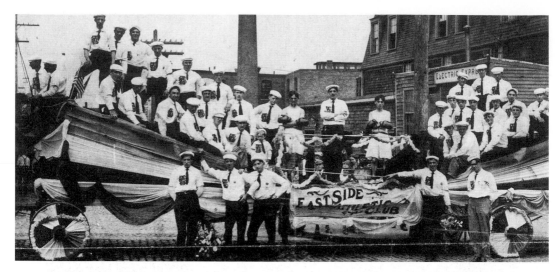

Members of the East Side Athletic Club pose on and in front of their float during a parade. Dressed in white shirts and caps, the men give a jaunty appearance, as well as a healthy glow, in this photograph from 1905.

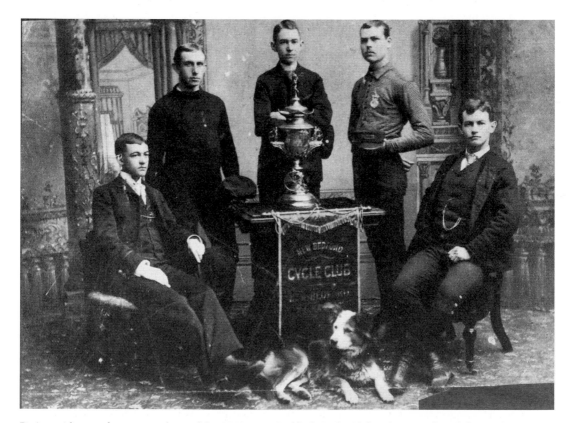

Posing with a trophy are members of the 1881 New Bedford Cycle Club. They are, from left to right, Frank Weaver, Fred Smith, Hoyland Smith, Mr. Sisson, and C.L. Dunham. Their mascot, seated at their feet, was the pet dog of Dr. A.F. Wyman.

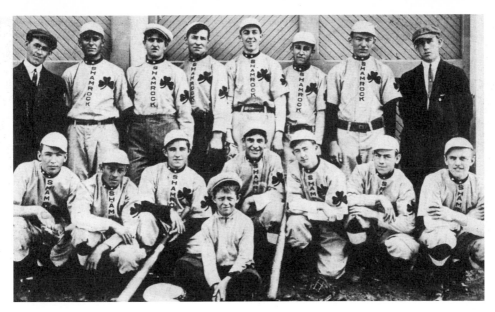

"The Shamrocks" were the 1910 champions of the New Bedford Amateur League. They included: (first row) Nip Dunkley, Buster Parker, Al Abrain, Jackie Manley, Clarence Trudel, and Rudy Blechinger; (standing) manager John Parker, Champ Sylvia, Ernie Jones, Tom Parker, Ernest Fredette, Oscar Bellenoit, George Duckworth, and John Calwell.

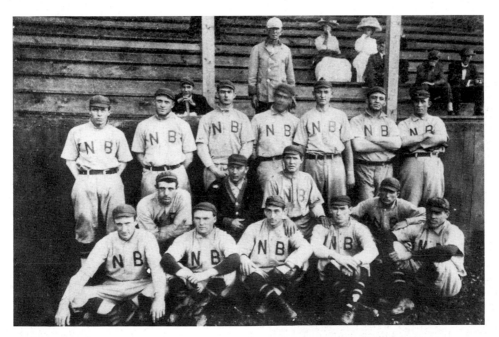

The champions of the 1910 New England pennant race were the New Bedford ball players. From left to right are: (first row) Armstrong, Griffith, Cunningham, Walsh, and Bauman; (middle row)Wilson, manager Tom Dowd, Pruitt, and McIntyre; (back row) McCrone, Pratt, Bushelman, McCormick, McTigne, Ulrich, and Rising. Standing behind the champions is Davy Burke, the grounds keeper.

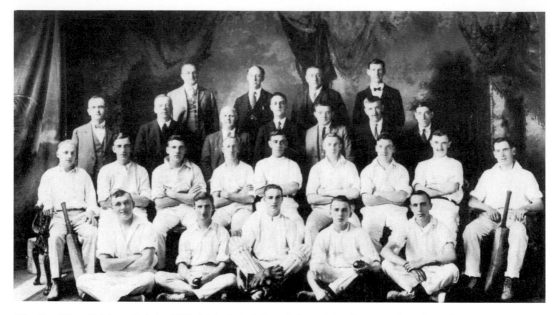

The Bay View Cricket Club in 1923–24 included, from left to right: (front row) Dick Walley, T. Eastham, M. Bates, H. Walley, and Harold Leach; (second row) R. Howarth, T. Law, B. Morris, W. Forman, and W. Astley; (third row) D. Holding, W. Dawson, A. Utley, W. Leach, W. Smith, J. Scholes, and Fred Catteral; (back row) Sam Heap, Albert Leach, Steve Dean, and A. Guy.

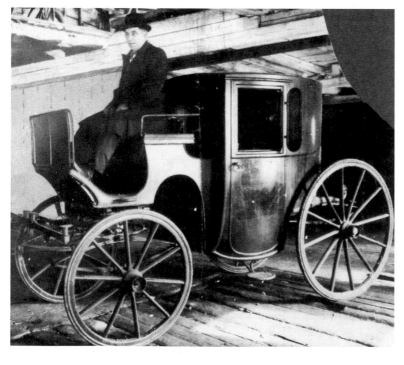

Edward Goulart sits in the driver's seat of this once-elegant brougham that was owned by C.H. Murphy and Sons. A brougham could be let by the day, or for a trip, and among the illustrious passengers who rode in it were Hetty Green, Edwin Booth, and Frank Bancroft.

ten

Transportation

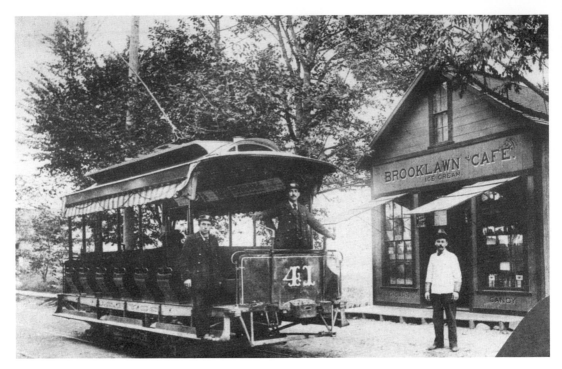

Streetcar No. 41 was headed toward Brooklawn Park when it was photographed in front of the Brooklawn Cafe *c.* 1905. David Allard is the motorman of this electric streetcar, which replaced the old horse-drawn streetcars. Brooklawn Park, at Acushnet Avenue and Ashley Boulevard, is still a popular place for picnics, tennis, and ice skating.

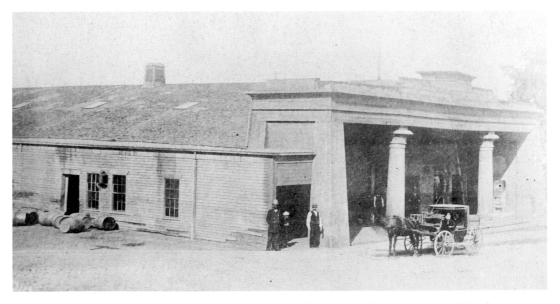

The New Bedford railway station was an Egyptian Revival depot on Pearl Street, just east of Purchase Street. A hackney cab is shown here drawn up in front of the station in 1884. The railroad opened on July 1, 1840.

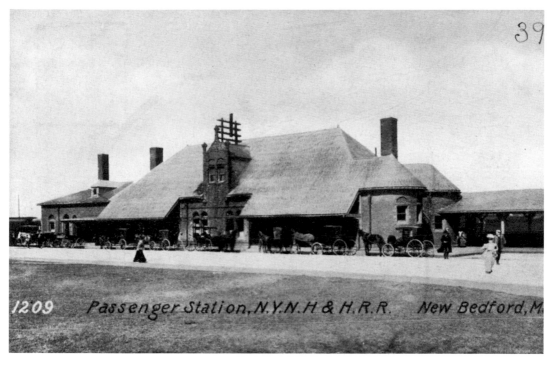

1209 Passenger Station, N.Y.N.H & H.R.R. New Bedford, M

The New Bedford railway station was rebuilt as a large Romanesque Revival depot of the New York, New Haven and Hartford Railroad. Hackney cabs are lined up outside the station awaiting passengers arriving from Boston about 1910.

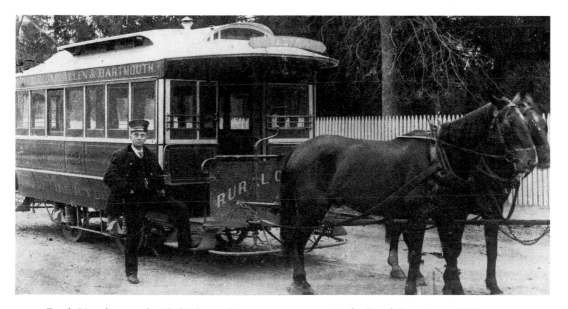

Frank Lincoln poses beside his horse-drawn streetcar opposite the Rural Cemetery *c.* 1885.

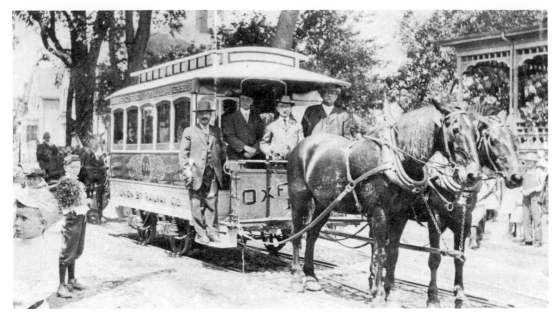

This horse-drawn streetcar is headed for Oxford Village on July 4, 1914. A group of celebrating residents took the streetcar, part of the Union Street Railway Company, to pleasure grounds in the country where a picnic and a summer afternoon could be enjoyed.

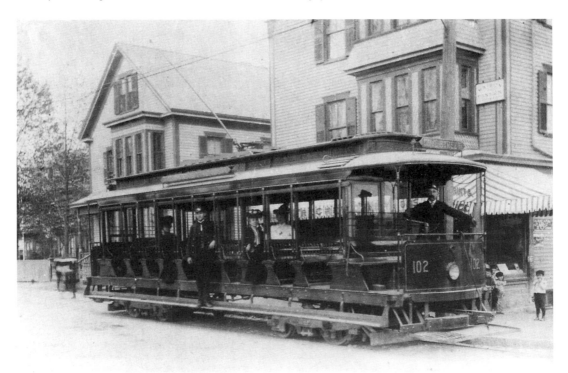

David Allard stands at the wheel of this "eight-wheeler" streetcar. The streetcar was stopped at the corner of Acushnet Avenue and Bullard Street *c.* 1905, and was headed toward Cove Street.

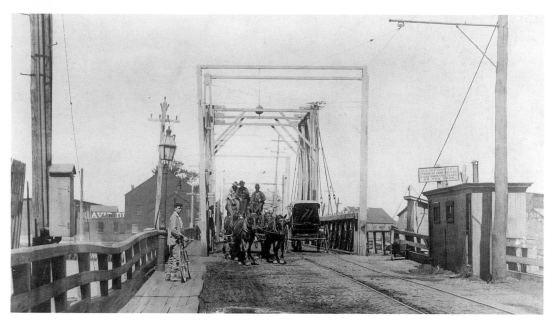

The old New Bedford and Fairhaven Bridge was a much-used bridge with a draw to allow boats and ships to pass under it. A young boy stands with his bicycle on a wood-planked sidewalk as a horse-drawn team crosses the bridge.

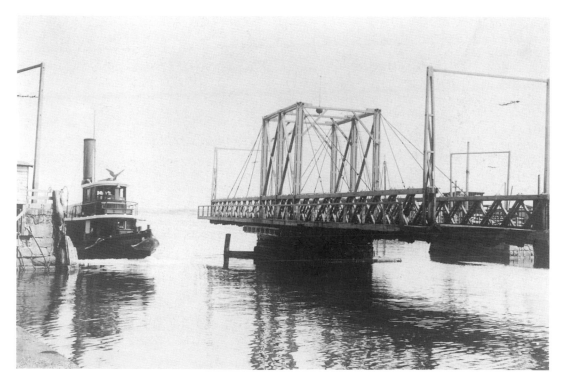

The draw of the old New Bedford and Fairhaven Bridge was open in 1893 to allow the tug *Nellie* to pass through.

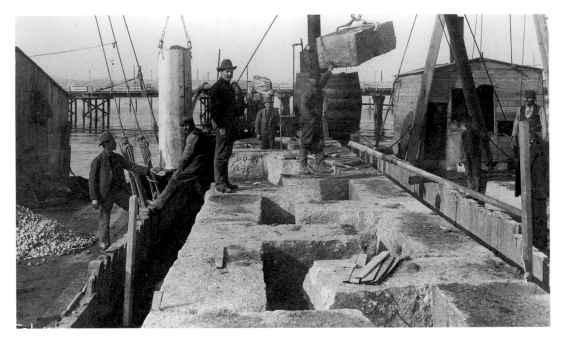

A new bridge was built between 1897 and 1898 to connect New Bedford and Fairhaven. Workers stand on a granite pier while a derrick lowers pieces of hewn granite in February 1898.

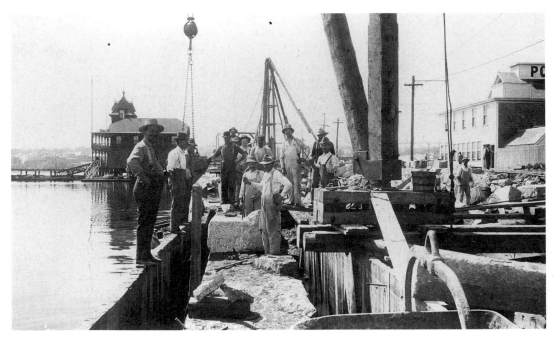

The south wall of the pier had workers standing on the granite pier with the clubhouse of the New Bedford Yacht Club in the distance.

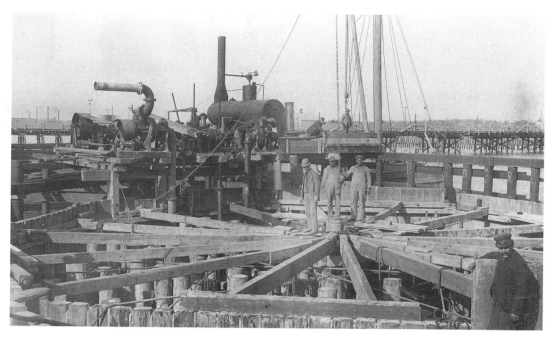

Workers stand on wood pilings that had been driven into the river bed to support the new pier. The piles and sheeting had been prepared for the draw pier foundation.

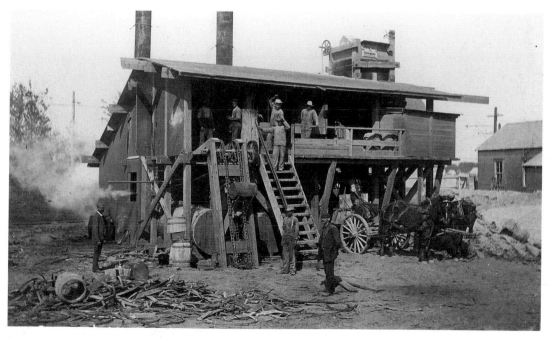

An asphalt mixing plant was specifically constructed to prepare the macadam that would be laid and rolled on the surface of the roadbed of the new bridge.

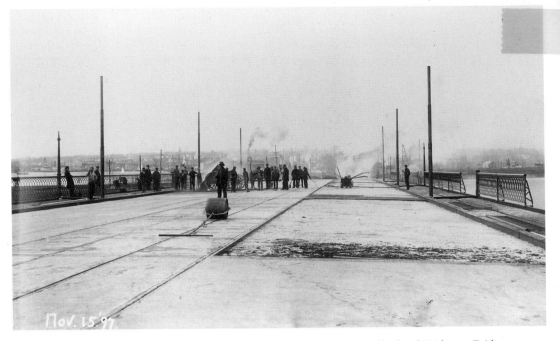

Workers are laying the asphalt on the superstructure of the rebuilt New Bradford and Fairhaven Bridge. A hand roller is in the foreground and tip carts are dumping macadam that will be spread for a smooth road surface.

Acknowledgments

This book could not have been produced without the assistance of many. The critical leadership demonstrated by Mayor Rosemary S. Tierney was most welcome. The enthusiastic support of the trustees of the New Bedford Free Public Library was appreciated. All of them—Mayor Tierney, Rev. Constantine S. Bebis, Mildred Barry, Carl Cruz, Cecilia Felix, Anthony Ferreira, Rose Ferreira, Dr. John Fletcher, Elsie Fraga, and Michael Hogan—contributed in their own way to the book.

Theresa Coish, Director of the Library, showed a sympathetic support throughout. Paul A. Cyr, Curator of Special Collections, with his encyclopedic knowledge of New Bedford history, was an exceedingly valuable asset to us, as were Joan W. Barney and Tina Z. Furtado, who were untiring in assisting us in the many details that made the book possible. We acknowledge our debt to all of them.

Also, the encouragement and assistance of Daniel Ahlin and Helen Buchanan are noted and appreciated.